THE JUKE JOINT KING
OF THE
MISSISSIPPI HILLS

THE RAUCOUS REIGN OF TILLMAN BRANCH

JANICE BRANCH TRACY

Published by The History Press
Charleston, SC 29403
www.historypress.net

Copyright © 2014 by Janice Branch Tracy
All rights reserved

Front cover, background: A. Lindenkohl. Created/published by U.S. Coast Survey, A.D. Bache, super intendent, 1865. *Library of Congress, Geography and Map Division, Washington, D.C., 10540-4650, call number: G3980 1865 .L53*; *inset*: Tillman Branch, pictured in 1928 while serving as a trusty at Parchman Prison Farm near Drew, Mississippi. *Branch Family Photo Collection.*

First published 2014

Manufactured in the United States

ISBN 978.1.62619.436.6

Library of Congress CIP data applied for.

Notice: The information in this book is true and complete to the best of our knowledge. It is offered without guarantee on the part of the author or The History Press. The author and The History Press disclaim all liability in connection with the use of this book.

All rights reserved. No part of this book may be reproduced or transmitted in any form whatsoever without prior written permission from the publisher except in the case of brief quotations embodied in critical articles and reviews.

To the living we owe respect, but to the dead we owe only the truth.
Voltaire (1694–1778)

This book is dedicated to my paternal grandparents, Clark Commander Branch and Lelia Porter Branch. They were born in Attala County, Mississippi, to parents whose ancestors had arrived there in the 1800s and who never ventured too far away from where they grew up. My grandparents were survivors of some very hard times early in their lives, having experienced the effects of the great Mississippi flood of 1927 and the severe economic conditions caused by the Great Depression. Throughout their lifetimes, they saw their friends, her brother, his nephews, their son, two grandsons and a great-grandson serve in the military during wars and conflicts that spanned a period of more than fifty years. Thanks to technological advances later in their lives, my grandparents were able to experience the conveniences and the benefits of three inventions my generation takes for granted: the telephone, the radio and the television. My grandparents experienced a variety of changes in social and political issues during their lifetimes, including the passage of the Civil Rights Act almost two decades before their deaths. And my grandmother lived long enough to see strong women like her finally given the right to vote in Mississippi, a right that also allowed a woman to serve as a juror in a court of law. They are my heroes, and I feel so fortunate to have known them.

CONTENTS

Preface .. 7
Acknowledgements ... 9
Introduction ... 11

1: A Place Called Holmes ... 15
2: The Editor and the Law ... 21
3: Makin' Moonshine .. 29
4: The Branch Family of Virginia and Attala County, Mississippi ... 31
5: Edward Tillman Branch ... 39
6: Marriage, Liquor and the Law .. 45
7: The Dry State of Mississippi ... 55
8: The Blue Flame .. 65
9: Tillman the Tough Guy .. 69
10: Tillman and Maxine ... 77
11: Big Jim Talks .. 81
12: The Arrest and Conviction of Matthew Winter 85
13: Winter's Appeal .. 89
14: The Right to Vote ... 93
15: Matthew Winter ... 97
16: Inez Talks about Tillman ... 101
17: Matthew Winter Tells His Story .. 105

Contents

Afterword	113
Appendix I: Notes	115
Appendix II: Court Transcriptions	119
Bibliography	147
Index	153
About the Author	159

PREFACE

As a young girl, I always heard the adults on my father's side of the family tell stories about their relatives and ancestors. Although most of the storytelling took place during once-a-year family gatherings in Goodman, Mississippi, when we celebrated the birthday of Claudia Baldridge Branch, my paternal great-grandmother, I heard other stories at home throughout my childhood. I was somewhat intrigued by what they said, especially the story of how one of our relatives, Tillman Branch, was a known bootlegger who sold liquor during a time when it was illegal in Mississippi. Older Branch relatives told how Tillman operated a nightclub, where his customers, mostly local black residents, drank, danced and gambled until the wee hours of the morning. I was still a child when I first heard how Tillman made a living, and I was certainly too young to understand anything about illegal liquor or what went on inside a nightclub. But as I grew older, I began to understand that some of Tillman's business dealings were illegal.

Fast-forward to 1997, when I began in earnest to research my Branch family's history. Very soon into the process, I traced my grandfather's ancestry back to a Virginia-born man named Edward Tillman Branch, my fourth great-grandfather. Later, research results showed there were four men of the name, including the Tillman Branch who owned a nightclub near Goodman, Mississippi, and that that Tillman was my father's first cousin, twice removed. After researching the Branch family in Virginia and in Mississippi for almost two decades, I decided to write about the man, one I never met, who was the subject of so many family discussions. Without

Preface

a doubt, Edward Tillman Branch, the third man to bear that name and known simply as Tillman, was my most colorful relative. And this book will tell his story.

ACKNOWLEDGEMENTS

Writing this book took the efforts of many individuals, and I would like to thank those who contributed their time and talents to help complete the project. First and foremost, I would like to thank my family, who supported the book when it was barely an idea and who were always available to help with whatever tasks needed to be done. I owe a mountain of gratitude to my husband who listened patiently as I read aloud pages of draft manuscripts and who helped ferret through miles of newspaper microfilms while we searched for relevant material about Holmes County, Mississippi. He also functioned as a second set of ears during some of the interviews. I am forever grateful to Christen, my editor, who was always available when I needed advice and guidance and whose edits and comments kept me on track with the book's content, as well as its schedule for publication. And there are so many others—friends and family who acted as sounding boards and offered suggestions during the planning process when I talked for hours about ideas for the book. I also want to thank the cousins, both old and new, who I encountered along the way. You were friendly and helpful, and you always made me feel welcome as you assisted me in sorting out time frames and many complicated relationships. One of those cousins to whom I owe special appreciation is Jim H. Branch, who grew up in Greenwood, Mississippi, but who now lives in Alabama with his wife, Ann. Jim spent many hours of painstaking efforts to ensure that I had access to some old and irreplaceable family photographs, and he helped match up names and faces in those photographs. Jim and another Branch cousin, Andy McCrory;

Acknowledgements

my brother, Arthur Branch; my father, James L. Branch; and Jennette Moore of the Goodman Library, assisted in taking (and retaking) various photos for the book. And I simply cannot forget to thank Ann Breedlove, a longtime genealogy researcher in the Attala County Library in Kosciusko, Mississippi, for faithfully assisting me with family research over a period of almost ten years. And to others who helped provide details for the book—including Bobbie Nance; Eloise Alderman, a historian in Lexington; and staff at the Mississippi Department of Archives and History who guided and assisted us with research activities on site—I offer my sincere appreciation.

INTRODUCTION

Most of the older residents of Attala, Holmes and a few surrounding counties have heard about the murder of Tillman Branch. And some of the younger people may have heard the story from their parents or grandparents when they were growing up about how he was shot and killed by a black man on Easter Sunday morning in 1963. Very few individuals I talked to during the course of writing this book, however, recalled the name Matthew Winter, the young man who killed Tillman. Strangely, some of these individuals included Tillman's close relatives. Generally speaking, Tillman's death went unnoticed in 1963 by most of Mississippi, primarily because some nationally significant events that same year kept local and national newspaper reporters and television stations otherwise engaged throughout the state. In March 1963, prior to Tillman's murder in April, the Student Nonviolent Coordinating Committee (SNCC) led a voter registration drive in Greenwood, Leflore County, adjacent to Holmes County, where he was killed. And just the week before Tillman was shot and killed, a contentious voter registration event took place in Lexington, Mississippi, the seat of Holmes County.

About five weeks after Tillman Branch was murdered, several hundred African Americans gathered in Jackson, where they asked for a meeting with the city's mayor, Allen C. Thompson, to discuss the city's hiring practices and its plan to desegregate the schools. Almost a week later, on May 27, 1963, Mayor Thompson did meet with representatives of the African American community and refused the group's demand for desegregation of Jackson's

Introduction

schools. The day after, on May 28, 1963, students from Tougaloo College, located just north of Jackson, protested the mayor's decision by staging sit-ins at Woolworth's lunch counter on Capitol Street, a few blocks away from Jackson's Central High School, my high school alma mater. National television news crews covered the sit-ins, which occurred less than three blocks from city hall, the state capitol building and the governor's mansion. Dozens of college and high school students participating in the sit-ins were heckled, beaten and arrested later that day. Protests continued in earnest on May 31, 1963, when several hundred students congregated at Farish Street Baptist Church near downtown Jackson and began what would be the first protest march in the city. According to most reports, somewhere between four hundred and five hundred protesters were arrested by police wearing riot gear and were detained at the state fairgrounds in what some believed to be less-than-humane conditions. Video recordings of the arrests and transportation of the protestors was memorialized in a PBS series entitled *Eyes on the Prize*.

The very next month, on June 12, 1963, Medgar Evers, Mississippi field worker for the NAACP, was shot and killed in his driveway, just blocks from where my paternal grandparents lived at the time. Almost two weeks later, on June 23, Myron de la Beckwith of Greenwood, Mississippi, member of the White Citizens' Council, was arrested and charged with the murder of Evers. And on August 18, 1963, James Meredith, the first African American to attend the University of Mississippi, graduated in Oxford. Another man also made history that same year—although it was in Washington, D.C., rather than Mississippi—when Dr. Martin Luther King delivered his "I Have a Dream" speech at a protest march on August 28, 1963.

During the 1950s and into the 1960s, it was uncommon, even almost unheard of, for a white man to be killed by a black man. But it had happened at least once before in the same county where Tillman was murdered, when Eddie Noel, a light-skinned black man, shot and killed a white bootlegger named Willie Ramon Dickard on January 9, 1954. According to the book *The Time of Eddie Noel*, written by Holmes County native and Yale Law School graduate Allie Povall, the altercation that ended with Dickard's death may have been caused by Noel's suspicion that Dickard was having an affair with his wife, Lu Ella Noel, who worked at Dickard's Store. Povall's book details the intriguing account of a massive manhunt for Noel, maybe the largest one ever seen in Mississippi, and one that resulted in several deaths of local individuals, including Holmes County deputy sheriff John Pat Malone Sr. In his book, Povall also tells the rather strange story of Noel's subsequent

incarceration and institutionalization in Whitfield State Hospital east of Jackson, as well as his eventual discharge. Interestingly, details contained in the book also describe how Noel may have been related to a former governor of Mississippi, a white man named Edmond Noel, a name that appears later in this book.

Since Tillman Branch, who was white, was killed in Holmes County by a black man during the racially charged 1960s, it is difficult to deny that racial issues somehow may have been involved in his murder. Tillman was around black people his entire life. For at least three generations, the Branch family had lived near black families in adjacent Attala County, where they hired black hands to work on their land. When Tillman was older and had children, he employed black women in his household, where they cooked, cleaned and cared for his children. And he primarily employed black people to work for him in his business establishments.

There are very few people still alive, however, who are old enough or willing to talk about the types of relationships Tillman had with his neighbors, employees or the hundreds of black customers who were known to frequent his businesses over the years. In fact, most of the people I interviewed in connection with this book, with very few exceptions, were unwilling to talk about racial issues at all. If they do recall that Easter morning when that young black man named Matthew Winter shot Tillman in the back, the moment they learned of his death is still etched in their minds. To many others who did not know Tillman or the man who killed him, his murder is just a part of some long-ago and almost forgotten incident in Holmes County history. And then there are some individuals who remember the incident well, but who don't want to talk about it at all. Whether the reasons for their silence are community pride, concern for the feelings of living family members or a fear of moral judgment in general still remains unclear. Although some of the characters in this book may challenge readers' belief systems, a look at their lives provides insight into what it was like to live in that time and place. As always, there are two sides to every story, and my resolve in writing this book was to present both sides of a tragic event that happened during some of the most difficult and unpredictable times in my home state. Hopefully, those of you who either know the story firsthand or who have heard it from others, or if you are reading it for the first time here, will consider my account a fair and unbiased one. And for that, I am thankful.

1
A PLACE CALLED HOLMES

Present-day Holmes County is a rather bucolic area of rural Mississippi, a place that is easy to miss if one takes a wrong turn off the major north–south highway that runs through the state. Located in the west central portion of the state, the county was created on February 19, 1833, out of lands originally ceded to the U.S. government by the Choctaw Indians in the Treaty of Doak's Stand. A national park sign on the east side of the historic Natchez Trace Parkway just north of Ridgeland, Mississippi, marks the ground on what was then known as the Natchez Road, where the treaty was signed with the Choctaws in 1820. According to the terms of the treaty, the Choctaw Nation ceded over five million acres of land in Mississippi in exchange for a parcel of land in Arkansas.

Neighboring Yazoo County, named for the Yazoo River that runs through it, and the Indians who lived there first, was formed out of the original large county of Hinds, where the state's capital city, Jackson, is located. Holmes County subsequently was developed from a portion of Yazoo County that included its crown jewel, an area of treed and rolling hills that was named by the Choctaw. Other counties lying adjacent to Holmes County are Attala to the east, Carroll and Leflore to the north and Humphreys to the west. Canton, the center of government for Madison County, is located just a few miles south of the Holmes County town of Pickens on U.S. Highway 51. In 1918, a portion of western Holmes County was used in the creation of a Mississippi Delta county named Humphreys, where almost a half century later, I was born.

Holmes County was named for Governor David Holmes, who was appointed by President Thomas Jefferson in 1808 to serve as the Mississippi Territory's fourth territorial governor. Holmes was born in York County, Pennsylvania, on March 10, 1769; however, his family moved to Virginia when he was a young boy, and he grew up in that state. At the time of his appointment as territorial governor of Mississippi, Holmes was serving as a U.S. representative from Virginia. In 1817, when Mississippi became a state, Holmes was elected to serve as its first governor, a position he held until 1820, when he was appointed to the U.S. Senate.

Between 1833 and 1837, Mississippi land offices are said to have sold over seven million acres of land, often on credit terms. Tens of thousands of people moved into the state, where abundant water, rich soil and available timber made the area an attractive one to farmers from the North and the East. Many of these farmers were seeking new lands for cultivation, since the lands they previously owned were depleted from years of growing the same crops. To some of these settlers, Holmes County seemed to be the perfect place to build a home, raise livestock and crops and rear a family. As new residents flocked to Holmes County and to other Choctaw lands that had recently opened up for settlement, small communities with names like Brozville, Durant, Ebenezer, Eulogy, Goodman, Richland and Dark Corner formed throughout the county.

The U.S. census of 1850 was the first to show the birthplaces of the people who were counted. According to that record, a large majority of Holmes County residents were born in the states of Virginia, Maryland, the Carolinas, Kentucky, Tennessee, Georgia and Alabama. Only a small fraction of these settlers, however, were born in foreign countries that included Denmark, Ireland, Sweden, Hungary and Germany. Within a very short time, a few settlers, like the Cox, Tolar and Ziegler families, had communities named for them, places that still exist today. As the years passed, the county grew and thrived, and relatives and friends followed those who had already settled and built homes. Like most early settlements in the United States, Holmes County is rich in its history, culture and traditions. Widely known as the birthplace of the Order of the Eastern Star, Holmes County has sixteen locations that are listed on the National Register of Historic Places in the United States. Among the buildings that appear on that list are the Holmes County Courthouse Complex; two historic areas of downtown Lexington; the Clifton Plantation House near Howard; the Tye House in Pickens, Mississippi; and the Little Red Schoolhouse (Eureka Masonic College.).

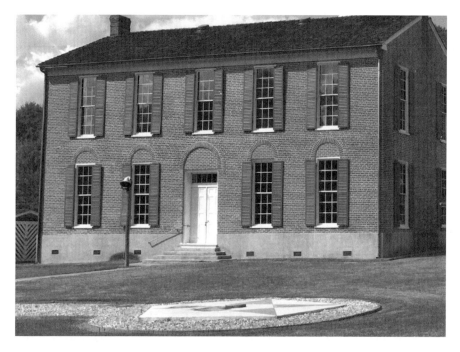

Little Red Schoolhouse near Richland Community in Holmes County, Mississippi, is known as the birthplace of the Order of the Eastern Star. *Author's photo collection.*

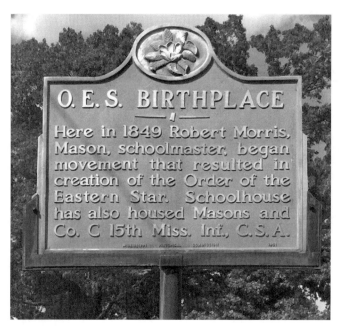

Historical marker for the birthplace of the Order of the Eastern Star, erected by the Mississippi Historical Commission. *Author's photo collection.*

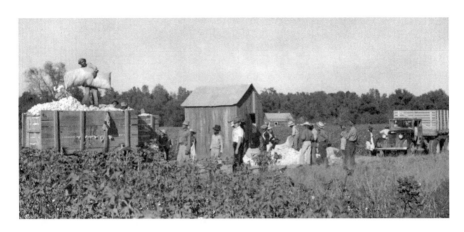

Mileston Plantation in the Delta land of Holmes County, Mississippi. Day laborers unloading cotton onto a wagon at the end of the workday. *From FSA Photography Collection, Marion Post Wolcott, 1939. Library of Congress Digital Collection.*

Mississippi Highway 12, Lexington's gateway from the Hills to the Mississippi Delta lands below. *Author's photo collection.*

When the Yazoo & Mississippi Valley Railroad was built in 1882, it played an important and formative role in the development and growth of business and commerce in Holmes County. Since the railroad connected the towns of Tchula and Durant with Lexington, the line allowed local farmers to ship homegrown produce to other markets to the north. Agriculture continued to drive the county's economy, and row crops, particularly cotton, were raised throughout the county. Several early large plantations—among them Egypt and Marcella (Mileston)—raised cotton on the flat, fertile fields. Cotton, sometimes called "white gold" or simply "king," was an economy of its own.

Holmes County's proximity to Greenwood, Mississippi, a cotton trade center in adjacent Leflore County, made it quite easy for Holmes County farmers to transport their cotton crops to market. From locations that made up Greenwood's now Historic Cotton Row District near a port on the Yazoo River, boats and barges heavily loaded with bales of cotton made their way southwest down the river until it merged into the Mississippi River just north of Vicksburg. From Vicksburg, cotton was shipped either north to Memphis, Tennessee, or south to New Orleans, Louisiana, where the largest cotton markets existed. Overall, the town of Lexington, as the center of the county's government and the hub of its agricultural, business and legal dealings, possessed a unique geographical location. The town literally sat atop the wooded hills where Chenoa Ridge dropped off into the vast, open farmlands of rich soil below. And it would be this location that made Lexington a natural gateway to the flat, rich land formation now known throughout the world as the Mississippi Delta.

2
THE EDITOR AND THE LAW

During the 1950s and 1960s, most counties in Mississippi, and other places in the South, in general, became racially charged places to live. In a publication entitled *Got to Thinking: How Black People in 1960s Holmes County, Mississippi Organized*, Liz Lorenzi Sojourner wrote about the five years she and her husband lived and worked as civil rights activists in Holmes County:

> *In 1963, in Holmes County, an oppressive, white-over-black system sustained the separation of races that slavery had created in Mississippi and the Deep South. A cruel, rigid segregation permeated all life and activities. In the 1960's [sic], the nineteen thousand Holmes blacks were still the underclass for the eight thousand Holmes whites.*

ILLEGAL LIQUOR AND ILLEGAL ACTIVITIES

Illegal liquor and its associated activities plagued Holmes County, as well. Throughout the 1930s, '40s, '50s and early '60s, Holmes County seemed to be hit the hardest by the consequences of bootlegging, gambling, bribery and sometimes prostitution. Crime had increased and domestic disagreements about drinking, gambling and the problems those two activities created were at an all-time high. Family disagreements and marital splits soared. It was not unusual for so-called family men to arrive home in the wee hours of

the morning barely able to walk in the door, reeking of alcohol, with very little left of a week's pay. And it was a pretty good bet they had traded their wages for a few hours of entertainment at one or more of dozens of the juke joints and gambling dens that lined the county roads. Politics in Holmes County and the surrounding area often made the front page of Lexington's newspaper, the *Lexington Advertiser*.

The newspaper's owner and editor, Miss Hazel Brannon, born on February 14, 1914, initially had purchased the *Durant News* in August 1936, shortly after she graduated from the University of Alabama. Allegedly, Brannon bought the newspaper with $3,000 she had borrowed from a local bank. Subscribers to the *Durant News* paid $2 for an annual subscription to "Mississippi's Leading Weekly," a descriptive phrase that appeared underneath the newspaper's masthead. Within four years, the subscriber list to the *Durant News* had increased to almost 1,500 individuals and businesses, and Brannon had repaid the bank loan. In 1943, Brannon mortgaged the *Durant News* and signed a promissory note for $4,000 that she used to purchase the *Lexington Advertiser*, Mississippi's second-oldest newspaper, and she became its editor. The holder of the note was a Durant businessman named Claud C. Wilkes.

Through Hazel Eyes

Although Brannon was still single when she arrived in Mississippi, the young, attractive brunette later married a man she met on an around-the-world cruise. After their marriage in Durant, Mississippi, Brannon's new husband, Walter Dyer Smith, left his job as purser on the ship and moved to Lexington to live with his new bride. As the couple would later discover, their life together in Lexington, Mississippi, would not be a peaceful one, as Holmes County community members soon chose sides in matters that dealt with the manufacture and sale of illegal liquor and, later, the desegregation of the state's schools mandated by the U.S. Supreme Court.

As activities related to illegal liquor reached an all-time high in Holmes County, Smith's newspaper articles and editorials spoke out against local bootleggers, the numerous clubs they operated throughout the county and the ill effects that liquor had on the lives of the area's residents. Consequently, the couple became targets for those who preferred to keep gambling dens open and illegal whiskey flowing in dozens of places that operated along the highways and rural roads. Interestingly, but certainly not surprisingly,

some of the owners, operators and supporters of the places promoting the illegal activities were county law enforcement officials. These officials found themselves in an extremely precarious situation. They had a lot to lose if they actually did the jobs they were elected to do: shut down illegal activities and clean up Holmes County.

The publisher herself wrote editorials and many of the other news articles that appeared in the *Lexington Advertiser*. Smith unabashedly and in very straightforward language addressed the county's illegal activities of bootlegging, bribery, gambling and prostitution. Often, she included the names of the individuals involved and directed her attacks on law enforcement people who allowed the activities to continue. In the years that followed, in a column aptly entitled Through Hazel Eyes, Smith frequently and vehemently spoke out against social and racial injustices she observed in Holmes County, and she specifically addressed the economic and social effects that illegal liquor had on families in the community.

THE PETITION

After the weekend murder of a young man in Durant in April 1946, reportedly by a drunken man, a large number of Holmes County citizens, including Hazel and Walter "Smitty" Smith, signed a petition that was presented to the Honorable S.F. Davis, Fourth Circuit Court District judge, asking that he reconvene the Holmes County Grand Jury to reconsider lawlessness in Holmes County. The grand jury had convened earlier, on April 1, 1946, to review alleged illegal liquor and gambling violations in Holmes County, but only six arrests had been made as a result of the grand jury's actions. In each case, varying amounts of illegal liquor had been confiscated, but illegal slot machines were left untouched in the whiskey joints. On Thursday, April 18, 1946, the *Lexington Advertiser* published a copy of the citizens' petition on its front page. The newspaper also published an editorial written by Hazel Brannon Smith, which called for Holmes County sheriff W.J. Murtagh to resign. The text of the petition submitted to Judge Davis follows:

> *To the Honorable S.F. Davis, Judge of the Fourth Circuit Court, District of the State of Mississippi.*
>
> *WHEREAS, the report in the press showed the Grand Jury empaneled Monday, April 1, 1946, duly sworn and charged by you for the regular*

April term of Circuit Court in Holmes County was in session for only one day, and was actually, in fact, in session for only about six hours, and WHEREAS, for a number of years, there has been increased violations of the laws regarding whiskey and slot machines in Holmes County; until, today there are numerous places which openly and flagrantly violate the laws of our state and county to such an extent that conditions in Holmes County are absolutely inexcusable and intolerable; and WHEREAS, we deem it the sworn duty of the Grand Jury to make a thorough investigation of matters brought before it affecting the general welfare of the people of Holmes County, and that Grand Jury, in fact, actually failed to perform its duty, therefore be it resolved, by the undersigned citizens of Holmes County that we respectfully and urgently implore your Honor to recall your Grand Jury and charge them with a thorough and complete investigation of lawlessness in Holmes County, particularly, the open sale of whiskey and display of gambling devices, especially slot machines, and instructing District Attorney Howard Dyer and County Attorney Pat M. Barrett to give their utmost cooperation to the matter of subpoenaing witnesses and bringing to the Grand Jury's attention all of the information possible bearing on these conditions with the purpose of placing the responsibility for such conditions in Holmes County and call for an accounting from those responsible for the same, and be it further RESOLVED, that copies of this resolution be given the Durant News, *the* Lexington Advertiser, *the* Memphis Commercial-Appeal, *the daily* Clarion-Ledger *of Jackson, and the* Jackson Daily News; *that copies of it be sent to the District Attorney and County Attorney. This, the 6th day of April, 1946.*

According to the newspaper account, Judge Davis told the jury the petition was "an indictment against the Grand Jury and every officer in this county." He further advised the jurors that if the petition was in fact true, it "speaks bad for the county," but if it was not true, "it was a libelous article against every officer" in the county. The judge charged the jury to "take the balance of this week to investigate conditions in this county and I don't mean maybe."

Smith's articles and editorials, coupled with the profound and very public accusation by over one hundred concerned citizen-petitioners, paid off a few weeks later when two places in Durant, Mississippi, were raided, and six arrests were made. But neither Smith nor the citizens who opposed liquor sales and the other illegal activities that followed were satisfied with the token arrests. The editor and many other county residents who opposed gambling

took issue with the fact that law enforcement officers who raided the two Durant establishments for illegal liquor had not confiscated the illegal slot machines inside. Published in the center of the *Lexington Advertiser*'s front page was an article with the heading "What about Slot Machines?"

The Indictments

Smith's outspokenness and tenacious spirit, and the support of citizens who wanted a return of law and order to their community, were rewarded the next month when dozens of indictments related to organized crime were handed down by the Holmes County Grand Jury in a one-day session. According to a front-page article of the *Lexington Advertiser* dated May 25, 1946, members of the grand jury included A.S. Gordon, Lexington; Luther Mayo, Lexington; Bit Kyzer, West; R.L. Netherland, Eulogy; Claude Harthcock, Tchula; Floyd Wilkerson, Coxburg; O.G. Grantham, West; W.E. Grace, Emory; Y.B. Bruce, Acona; Nick Helms, Pickens; H.R. Varnado, Pickens; W.E. Hill, Emory; Willie R. Hocutt, Lexington; C.C. Booth, Tchula; George G. Reynolds, Lexington; J.V. Waddell, Bowling Green; R.H. Gage, Lexington; J.W. Cunningham, Tchula; W.L. Edwards, Eulogy; and S. V. Farmer, Lexington.

An elderly gentleman who grew up in the Holmes County community of Coxburg and who did not want his name published described the aftermath of the indictments. He related how individuals convicted of federal charges and sentenced to serve time in prison gathered early one morning at a government-designated pickup point in the town and were transported en mass in school buses to the Atlanta Federal Penitentiary in Atlanta, Georgia. The individual added that it was a "sad day for Holmes County, Mississippi," since these imprisonments left dozens of "widows and orphans" behind in a county where many of the men had owned land and had farmed. Taking care of the family farm, in many instances, was left to the women and children until the men completed their sentences and returned home.

Corruption and Civil Rights

Later, in the 1950s, Hazel Brannon Smith made national news again when she publicly denounced the mistreatment of black people by law enforcement.

In addition, Smith again condemned corruption within the county at large. Both actions angered Sheriff Richard F. Byrd Jr., who had been involved in an alleged racially motivated incident in Tchula, Mississippi. In an act that seemed very much like retaliation against Smith for a news story she had written describing the incident in Tchula, in which Sheriff Byrd allegedly shot a black man in his thigh without cause, Byrd successfully charged Mrs. Smith with contempt of court. Sheriff Byrd's action was based on the fact that Smith attempted to interview a black woman who had just testified at the trial of five white men accused of killing the woman's husband. Smith had entered the courtroom late, after the woman had sworn that she would not discuss the case outside the court. Smith apparently approached the witness as she left the courthouse and attempted to interview the woman. As a result of the contempt charges, Smith was ordered to appear before the judge, who fined her fifty dollars and sentenced her to a probated sentence of fifteen days in the county jail, provided she "stayed out of trouble." Smith appealed the case, and the Mississippi Supreme Court later overturned the conviction. Although Sheriff Byrd may have intended to harm Smith's reputation, the incident and court decision had the opposite effect: news outlets throughout the country picked up the story about the small town female editor and the sheriff.

THE END OF AN ERA

Hazel Brannon Smith's outspoken manner and activist spirit, evident in the editorials and articles she published about corruption and later civil rights soon caused her and her husband to suffer a form of discrimination themselves. The couple received death threats and threatening phone calls, and eventually, Smitty was terminated without cause from his job as an administrator of the hospital in Lexington. The latter event caused Smith, an experienced businessman and a photographer, to join his wife at work on the newspaper. On another occasion, a group of young white men burned a large cross in the couple's front yard. Hazel and her husband soon found themselves fighting a losing battle against activities spearheaded by the White Citizens' Council in Holmes County when its members began publishing another newspaper in Lexington. Started in 1959, the *Holmes County Herald* was founded for the single purpose of countering the editorials and articles Smith wrote about corruption and racial unfairness in the county. Seemingly, the new publication was aimed at destroying

Smith and her newspaper, the *Lexington Advertiser*. Smith's personal life took a turn for the worse, too, when her beloved Smitty died from injuries he sustained in an accident at their home.

 Smith attempted to keep the newspaper offices open and the weekly news journal in print. But financial woes that were caused in part by decreased advertising and fewer subscription renewals caused Smith to close down the newspaper office. Shutting down the presses and closing the doors of the *Lexington Advertiser* was a sad end for a newspaper that had reported local, state and national news for over 150 years. And it was the end of an era for its editor, too, who soon filed for bankruptcy protection and eventually left her adopted state.

 Hazel Brannon Smith's opinions and efforts to stand up for what she thought was fair and right, even when she was opposed vehemently by many in the community, were rewarded, however, by state and national press groups. In 1964, the editor of a small-town newspaper in Mississippi became the first woman to receive a Pulitzer Prize for editorial writing. Three decades later, Smith's story was the subject of a television movie, *A Passion for Justice*, in which the editor was portrayed by the well-known and talented actress Jane Seymour. And in 2000, John A. Whalen, a veteran newspaperman himself, published the book *Maverick among Magnolias: The Hazel Brannon Story*.

3
MAKIN' MOONSHINE

By the 1920s, making moonshine and selling illegal whiskey had become fairly large business operations in Attala and Holmes Counties. Adjacent to each other, with plenty of wooded areas to hide the manufacturing equipment, called stills, the two counties were perfect havens for making and selling moonshine. Often referred to as "white lightning," "shine," "hooch" or "mountain dew," the stills' product, a clear and potent liquid, was made from corn mash and a sweetener such as molasses to speed up the fermentation process. Since corn was a crop that even an inexperienced farmer could grow, thriving with little or no attention at all, would-be moonshiners had the most primary and essential ingredient growing just outside their doors. Every farmer raised corn to feed his hogs, and shelled corn was ground into that popular southern staple, cornmeal, the main ingredient used in making cornbread and flapjacks. The fact that corn was in such high demand, even without moonshine production, made local gristmills important and very lucrative businesses in these rural communities. But throughout the next several decades, some might say that whiskey stills far outnumbered gristmills in rural Attala and Holmes Counties.

Before liquor was legalized in Mississippi in 1966, making a little corn whiskey, though illegal, certainly was not unusual. In fact, according to an article in the *Holmes County Herald* published less than a decade ago, a man was arrested when a moonshine still was discovered in Durant, Mississippi, just northeast of Lexington. As one looks back into the early part of the twentieth century, a rural Mississippi homestead commonly included a

frame house that, with some luck, kept varmints out and the family safe and warm; a wooden barn to protect livestock; a smokehouse; an outhouse; and a corncrib. A common addition to the homestead most likely was a working whiskey still hidden in the woods behind the barn. Historically speaking, owning a still was not unusual. Men have made their own liquor for centuries, and whiskey stills and instructions for homemade liquor often were passed down from fathers to sons. When researching and reviewing old wills, it is not uncommon to read that a father left his whiskey still and relevant equipment to a son, brother, nephew or close family friend. But when Prohibition was voted in, all that changed—at least in some places.

Whiskey stills in twentieth-century rural Mississippi were commonly made of cast-off metal or other fireproof containers and were hidden in the midst of tangled vines and dense woods. Unless the owner could afford a copper apparatus or expensive fireproof glass, the stills were neither sophisticated nor complicated. A whiskey still served simply as the means, and the clear liquid, simply known as corn whiskey, was the end result. The amount of whiskey produced was an important factor, but often the quality of the product was not. Since wood fires were used to cook the corn mash, an effective and efficient moonshine still needed careful watching in order to prevent the fire from getting out of hand, an act that could burn up everything in sight. The distillate produced by the still was an extremely flammable substance itself, depending on the percentage of alcohol it contained. As an example, if the liquid produced by the still contained 70 percent alcohol, its flashpoint was 70.

More often than not, the whiskey maker cooked up the corn mash at night. Since the light from the moon was the only light available, the product became known as "moonshine." An added advantage of cooking up the mixture at night was that the smoke produced by the fire that heated the still was almost invisible, something that prevented anyone else, including revenue agents, from finding the still. Also, tending a still meant knowing how to test the quality of the hooch. A common folk test for the quality of moonshine was to pour a small quantity of it into a spoon and set it on fire. The theory in practice was that a tainted or imperfect product burned with a yellow flame, but a safe distillate burned instead with a blue flame. In 1963, a bootlegger named Tillman Branch would die in a Holmes County juke joint that was known as the Blue Flame.

4
THE BRANCH FAMILY OF VIRGINIA AND ATTALA COUNTY, MISSISSIPPI

When Edward Tillman Branch, known as Tillman, was born in 1901, he was the third Branch male to bear the name. Tillman was named for his father, and his father, in turn, was named for his own father, the original Edward Tillman Branch. Tillman's grandfather migrated to Mississippi in the early 1800s and married his wife, Winiford Ragland, in Hinds County in 1830. By 1850, the couple had settled in the small rural farming community of Newport, in Attala County, near Kosciusko, where they raised their children, including a son named Edward Tillman Branch. That son grew to adulthood and married a young woman named Nettie Artissa Ousley. And on November 15, 1901, Tillman, their youngest child and the subject of this book, was born.

Kosciusko

Attala County was named for the Native American heroine of a fictional nineteenth-century novella, *Atala*, written by François-René de Chateaubriand. The county was rich in natural resources that included water, timber and fertile soil. Spring-fed springs were plentiful and abundant, providing residents with clean, cold water. And a river called the Big Black provided access to points to the southwest, including the historic town of Vicksburg. Attala County was formed from some of the

Historic Attala County Courthouse, built in 1897, graces the downtown square of Kosciusko, Mississippi. *Author's photo collection.*

counties that lay adjacent to it, including counties named Montgomery, Choctaw, Winston, Leake, Madison, Holmes and Carroll. Attala and Holmes Counties share a common boundary, and the bridge over the Big Black River at Goodman affords Attala County residents easy access into Holmes County and to U.S. Highway 51, which runs north to Memphis and south to Jackson and beyond.

Attala County's history dates back to the Treaty of Dancing Rabbit Creek, signed by the U.S. government and the Choctaw Nation in 1830. On December 23, 1833, as a result of this treaty, Attala County was one of sixteen counties created out of lands ceded by the Choctaw. As the smallest county in Mississippi, Attala contains slightly less than eight hundred square miles of land. Kosciusko, situated in the Mississippi Hills, is the seat of government for Attala County. It is a small, charming and historic town with old houses on tree-shaded streets—a town voted in recent years as one of the "Top 100 Best Small Towns to Live" in the United States.

The historical town has seen its share of history unfold on its streets, in its business establishments and in its historic courthouse. Sitting in the

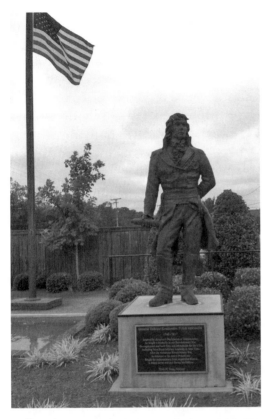

Left: Life-size statue erected near downtown Kosciusko, Mississippi, in honor of Thaddeus Kościuszko, the Revolutionary War soldier for whom the town was named. *Author's photo collection.*

Below: Commemorative plaque near the statue of Thaddeus Kościuszko, explaining his connection to the town. *Author's photo collection.*

General Tadeusz Kosciuszko, Polish nationalist
1746 - 1817

Inspired by America's Declaration of Independence,
he fought voluntarily in our Revolutionary War.
He engineered and built forts and strongholds for the USA
including West Point Military Academy in New York.
After the victorious Revolutionary War,
he returned to his native Poland and
fought for independence from Imperialist Russia,
a dream never realized during his lifetime.

Tracy H. Sugg, Sculptor

middle of a quaint downtown with colorful storefronts, the large-columned, stately courthouse was the setting for several infamous trials over the years, including one that would become part of Mississippi's well-documented and contentious racial history, the trial of Leon Turner. Some houses dating back to the 1800s still grace the streets that surround the town square, reminding visitors to Kosciusko of the people who once sought to make their town the center of Mississippi's culture and education.

Off to the northeast, barely more than an hour from Kosciusko, is Starkville, Mississippi, home of Mississippi State University. An institution that is well known for its engineering and veterinarian schools, "State," as the university is referred to by the locals, is also known for its beloved Bulldogs athletic teams. A couple of hours or so due north from Kosciusko sits the better-known town of Oxford, home to the University of Mississippi, known to native Mississippians as "Ole Miss." And it was in Oxford in 1962 that James Meredith became the institution's first black student.

Kosciusko was named for Tadeusz (Thaddeus) Kościuszko, a friend of Thomas Jefferson, who was a native of the Polish-Lithuanian Commonwealth now known as Belarus. It is believed that Kościuszko shared some of Jefferson's beliefs, including those concerning human rights. A graduate of the War College of Warsaw, Kościuszko was one of many foreign-born military men who helped U.S. Patriots in their fight to extricate themselves from British rule. Kościuszko served as a colonel in the Continental army, and because of his heroic service in the war, he was elevated to the rank of brigadier general. Some years later, Kościuszko left to return to his native Poland, and subsequently died in 1817 in Switzerland.

Quite possibly, however, Oprah Winfrey, well-known television host and media mogul, may be Kosciusko's best-known former resident, one who has a city street, Oprah Winfrey Boulevard, named in her honor. James Meredith, mentioned earlier, is also a former resident of Attala County with ties to the Buffalo community. In one of his several books, Meredith has written about his tri-racial history and his familial ties to at least one of Attala County's oldest families.

Edward Tillman and Nettie Ousley Branch

Edward Tillman Branch ("E.T.," as he was called) and his wife, Nettie Artissa Ousley, grew up in Attala County, where his family had farming

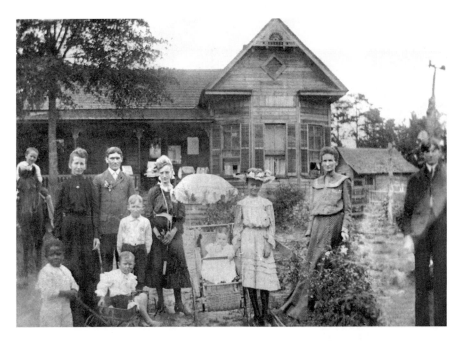

Branch family, pictured in front of the old Branch home near Newport, Mississippi, circa 1906. Tillman Branch is the young child sitting in the wheelbarrow. *Branch family photo collection.*

interests. He and Nettie would raise their own family in Newport, a small close-knit farming community southwest of Kosciusko, just off the road that went to Goodman.

Nettie was the daughter of Nicholas Nixon Ousley and his wife, Mary Ann Mabry, whose families lived nearby on land they owned. The Mabry and Ousley families, like the Branch family, had ancestral ties back to the state of Virginia, where early members of the Branch family had lived since the 1600s. It seems likely that members of these three families, related through marriages, already knew each other before they migrated to Mississippi. According to my review of Attala County deed records for the latter half of the 1800s, all three families owned land in the county and had deeded parcels of land back and forth during that fifty-year period. They made their livings from the land they owned and were active in the community and in its schools and churches. But as years went by, family members became involved in local businesses, too, and a few sought out training in some of the professions. Although the story has not been substantiated, several older relatives recall hearing that E.T. Branch was fascinated with the law and maintained an extensive law library. At least one of these individuals is old

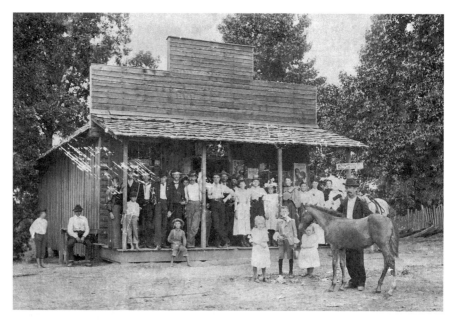

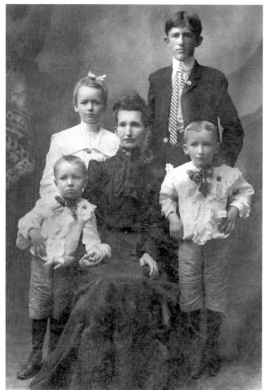

Above: Extended Branch family, pictured in front of the old Branch Store in Attalaville, Mississippi, circa 1900. *Branch family photo collection.*

Left: Nettie Ousley Branch and four of her children, circa 1906. Each person is wearing a Victorian "funeral pin" bearing their deceased father's picture. Tillman is standing next to his mother, holding her hand. *Branch family photo collection.*

enough to remember seeing some of Branch's old law books. As the years passed, E.T. Branch and Nettie produced a large family that included William Thomas, Benjamin Harrison, Callie Ella, Mamie Winifut, Frederick Mabry and Henry Clay, who died when he was three. Their youngest child, Edward Tillman Branch—"Tillman," as he came to be known—was born in 1901.

Some members of the Branch family, including myself, own a copy of a letter that E.T. Branch wrote to his youngest daughter, Mamie, on April 3, 1902. The sheet of paper on which the letter is written contains the letterhead of the Electro-Chemic Institute, 1010 Canal Street, New Orleans, Louisiana. According to the contents of the letter, E.T. Branch was undergoing treatment in New Orleans for a condition or illness that ultimately caused his death later that year. The handwritten letter is lovingly addressed to "My Darling little Mamie" and includes the closing, "From your Sick Papa, E.T. Branch." At least one Branch family member told me that E.T. Branch died of colon cancer, but neither the exact nature of his illness nor the actual cause of his death can be confirmed, since the state of Mississippi did not require the filing of death certificates prior to 1912. Some clues about the possible illness that affected E.T. Branch may exist in information contained in the letterhead, which identifies the Electro-Chemic Institute as a place that treated "catarrh, consumption, asthma, bronchitis, deafness, disease of the stomach, liver, kidneys, and bowels." Based on the tone of the letter to his young daughter, E.T. Branch sounds as if he were a kind and loving father who dearly missed his little daughter. But E.T. Branch would not live to see his young children grow to adulthood, as he died on November 6, 1902, little more than a week before his youngest son, Tillman, would celebrate his first birthday.

After his death, E.T. Branch was buried in Seneasha Cemetery, in rural Attala County, near the grave of his young son, Henry Clay Branch. With burial sites dating back more than a century, Seneasha Cemetery has become the final resting place for several generations of Branch and allied family members that include deceased members of the Ables, Allen, Baldridge, Burrell, McCrory, Mabry and Ousley families. Now that her husband was dead, Nettie Ousley Branch, still a young woman, was left with the rather enormous task of raising their children alone.

5
EDWARD TILLMAN BRANCH

Some of the later events in Tillman Branch's life may have been affected by the simple fact that he never knew his father. Tillman and his older siblings, including brothers Benjamin Harrison Branch, William Thomas Branch and Frederick Mabry Branch and sisters Callie and Mamie, were raised by their mother, who certainly must have had some help from other members of the Branch, Mabry and Ousley families. According to the U.S. census of 1910, recorded almost a decade after her husband died, Nettie Branch, a forty-seven-year-old widow, was living in the Newport community of Attala County, very likely in the same household where she had lived with her now deceased husband. Nettie's household included her children and her deceased husband's older brother, a seventy-two-year-old widower, Joe (Joseph Arthur) Branch, my paternal great-great-grandfather. Tillman's sister Callie, who had already married a young man named Hal Albin from nearby Attalaville, was no longer living in the house with her mother, her siblings and their uncle Joe. According to stories told by my paternal grandfather, Clark Branch, who was Joe's grandson, his grandfather was blind. Although one might believe Joe was affording his sister-in-law either male protection or help with her children by living in the household, his blindness likely prevented him from rendering much help at all to either Nettie or his nieces and nephews.

In 1900, the U.S. census listed Joe Branch as a resident in the household of his only child, Edward Arthur "Ed" Branch, my paternal great-grandfather. Based on family recollections, Joe Branch lived with Ed and his wife, Claudia

Baldridge Branch, and their children after the death of Joe's wife, Mattie Allen Branch. Since Ed and "Claudy," as my great-grandmother was known, already had five children by 1910, including my grandfather, it is possible the couple no longer had room for Joe. But without other family information or some type of hard evidence, it is purely speculation as to why Joe was living with his sister-in-law and her children in 1910.

Tillman was eight years old when he was enumerated on the 1910 census, the youngest of the five children living in his mother's household. In addition to Ed Branch and his family, a further review of that census identified other members of the extended Branch, Mabry and Ousley families living in proximity to Nettie and her children. According to one older individual whose parents knew Tillman when he was a boy, Tillman's childhood years were spent like those of other boys of that age at that time. He liked to climb trees, run and play, shoot squirrels, fish and pitch rocks in the clear spring-fed streams that ran through the wooded Attala County hills. He also recalled hearing from older relatives that Tillman, as the youngest child in the family, was spoiled a little by his mother, his older siblings and his extended family members.

Clark Branch's father, Ed Branch—Tillman's first cousin, but a generation older—and his wife, Claudia, also lived in Newport where Tillman grew up. Ed's father was the seventy-two-year-old Joe Branch who was living with Tillman's widowed mother and her young children in 1910. Neither Ed Branch nor Joe Branch, however, would live long enough to provide much male influence in Tillman's young life. Ed, Joe's only child, died of cancer in 1915, and left a widow and four young daughters—Stella, Ezma, Laura and Catherine—as well as my grandfather Clark Branch, who was fifteen years old at the time of his father's death.

My grandfather and Tillman—his first cousin, once removed—were only two years apart in age, and they shared something that drastically changed their lives: each had lost his father. But one defining difference existed in the lives of these two young men. My grandfather, as Ed Branch's only son, suddenly became the "man" of the house and responsible for supporting a mother and his unmarried sisters. Tillman, on the other hand, was much more fortunate than his cousin. He had older brothers and sisters, as well as numerous aunts, uncles and cousins from his mother's side of the family, who lived nearby. Without a doubt, however, the availability of relatives who were willing to help could not have filled the void that Tillman must have felt growing up without a father.

The Branch family had once been among many prominent families who settled in Attala County, since they owned land and businesses and made a

good living. But family deaths and the passage of time changed many things. Attala County deed records show that acres of farmland and timber were sold and resold even before E.T. Branch died in 1902. As the years passed and Tillman's generation grew to adulthood, some of the men of his age left Attala County and sought work in bigger towns where non-farm-related jobs were more available. Those who could afford it bought land in the Delta and attempted to make a better living farming on the rich land there. Still others who lost their land for various reasons, including family deaths or debts, were forced to become sharecroppers on someone else's land. And with the outbreak of World War I, many of the county's men registered for the draft in 1918 and 1919 and went off to fight in the war.

There is no information available to show that Tillman either registered for or served in World War I. However, World War II military enlistment records available through Ancestry.com establish that Tillman reported for service on October 15, 1942, at Camp Shelby, Mississippi. The record shows Tillman was seventy-two inches tall, and his rank was shown as "private." According to the enlistment record, Tillman's civil occupation had been that of "café and restaurant manager."

The economy in the early 1900s in Attala County, where Tillman had grown to adulthood, was based primarily on agriculture and timber. Families raised their own food, including animals and produce, and cash crops, such as cotton. They also sold timber, cut from their own land, to the many sawmills that dotted the rural landscape. In later years, some land in the county would be leased for oil and gas exploration, although only a few received much money from the leases. Often, to supplement their family's income from farming and livestock operations, the younger men worked in sawmills or went to work for the railroads that had gradually become part of the local landscape. Others, like one of Tillman's cousins—my paternal grandfather, Clark Branch—left Attala County for a time to work on a Mississippi riverboat, the *Kate Adams*, in order to help earn a living for his widowed mother and sisters. Without a doubt, however, manual farm labor, which must have included raising crops and tending to animals, certainly played a large role in Tillman's work life during early years.

There are only a few relatives still living who can provide insight or actual details about Tillman's formative years, so it is difficult to know who served as his role models in the absence of a father. His older brother Benjamin Harrison Branch—or "Ben," as he was known—may have served as a father figure to his younger brother. At least one document I reviewed during research for this book showed that Tillman referred to Ben as his

"guardian." Attala County residents placed a very high value on formal education, as evidenced by numerous schools that grew up in and around Kosciusko, even in the rural areas. But only anecdotal information exists about where or for how long Tillman attended school. The best evidence available is information provided by Tillman himself years later on a World War II draft registration record in 1942, stating he had completed four years of high school.

Without a father to guide him as he grew to manhood, it seems as if Tillman grew up very fast. Remarkably, he didn't seem to stray very far from his early roots. Older individuals and a few relatives recall that he worked for a brief time on the Illinois Central Railroad as it was extended through Mississippi to Memphis. But they also said that he returned to the place where he was born and raised when the job was complete. Others recall that he raised cotton on the land he and his family owned and that he and his brother Ben may have operated some type of trucking company near Sidon, Mississippi, in Leflore County, for a while in the 1930s. But there is no information available that establishes an exact timeframe when Tillman began making and selling moonshine. He must have started making moonshine at a fairly early age, however, since archived records available at the Mississippi Department of Corrections verifies that he served slightly less than two years at the state prison farm in Drew, Mississippi, for "manufacturing liquor" from 1929 to 1930. But old habits die hard, and soon after his release from prison, Tillman again was involved in making and distributing moonshine. Some even believed that Tillman, at one time, was one of the largest manufacturers and distributors of moonshine in the entire state.

Firsthand information about Tillman's adult life has been fairly difficult to come by, as well, since there are a limited number of people who are still alive and willing to discuss the man or provide details about his life. But several who have offered information about Tillman, including my father, recall that he was a kind man with a big heart. A generation younger than Tillman, my father remembers his older cousin as a generous man who was willing to help others during times of need, often reaching into his pocket and handing them some cash to pay a bill or buy food. My father liked to hunt when he was younger, and he recalls how Tillman sometimes gave him money for shot guns shells when he was a boy growing up in Attala County. In return for money to buy the shells, my father killed squirrels that he would give to Tillman. My father also admitted, albeit with some reluctance, that when he was older, Tillman occasionally handed him a

bottle or two of moonshine liquor on the sly, something his parents would not have liked at all.

When I mentioned the squirrel hunting incident to another cousin, she related how Tillman often paid other individuals to catch fish for him. According to this individual, Tillman had diabetes and had been advised that eating fish was healthier than eating animal meat. Tillman's efforts to control his diabetes with the food he consumed likely explains why he paid my father to kill squirrels for him. It is an accepted fact that squirrels, along with some other forms of wild game, are much lower in fat and cholesterol than most domestic meats.

6
MARRIAGE, LIQUOR AND THE LAW

Tillman's earliest recorded adventure into adulthood was actually before he became an adult. According to Attala County marriage records, he was still a teenager when he married Bessie Dickerson, also in her teens, on August 26, 1917. According to the U.S. census of 1920, Tillman was eighteen years old when he was enumerated as the head of a household in Newport, located in Beat 4 of Attala County, near where he was born and where he grew up. Living in the household with Tillman, according to the census record, was Bessie, his sixteen-year old wife, and their young son, James Edward Branch, who was one year and five months old. During the next few years, Tillman and Bessie's marriage produced three more children—Helen, Mae Bess and Edward Tillman Jr.—before their relationship effectively ended when Tillman went to prison. The young couple's marriage likely was strained by several other events, including the fact that they married young and had four children within ten years. But the marriage may have been strained even further by an event that now has become part of Holmes County folklore and a vignette of Holmes County law enforcement history, as well: Tillman shot the marshal.

Marshal Moody

Allegedly around 1925, when Tillman was still a young man in his twenties, he shot Goodman marshal James Robert Moody in downtown Goodman,

Mississippi. Although several versions of this story exist, the most factual account came from an Attala County man named John Henry Lepard, whose father, John Alec Lepard, told him the story years ago. According to Lepard, his father knew Tillman and was a teenager when the Goodman incident occurred. Lepard's father recalled that Marshal Moody observed Tillman driving his Model T at a dangerous rate of speed down Goodman's Main Street. At some point, Tillman stopped the car, and Moody approached him. At that point, the marshal issued Tillman a verbal warning that he was driving too fast and advised him to slow down before someone got hurt. Apparently Tillman became angry and told the marshal that he could drive as fast as he wanted, and he began to drive away. Supposedly, the marshal jumped up on the running board of the Model T in an effort to make Tillman stop the car, but when he did so, Tillman shot him in the chest. Marshal Moody fell backward onto the street, and Tillman sped off in the Model T. As an afterthought, perhaps, Tillman turned the car around and immediately drove the Model T over Moody's body.

There is no information available that tells whether Moody died as a result of the gunshot wound or from being run over by the car. And there is no information that tells exactly what happened, if anything, to Tillman, after he killed the marshal. Lepard, along with my father and others who know about the incident, recall hearing their elders say that Tillman served

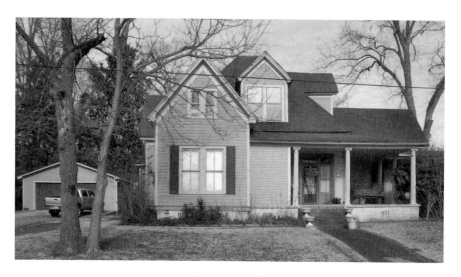

Former May Street residence in Goodman, Mississippi, of Marshal Moody, who was shot and killed by Tillman Branch in the 1920s. *Photo by Jennette Moore.*

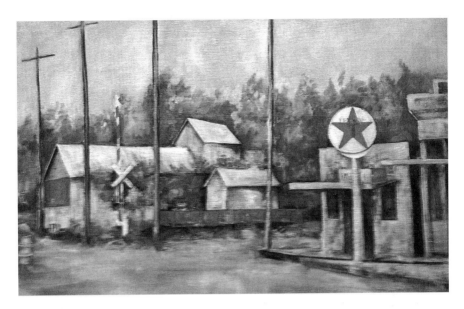

Artist's rendition of Goodman's Main Street, circa 1920s. *Author's photo collection, photographed with permission of Goodman Public Library, owner of painting.*

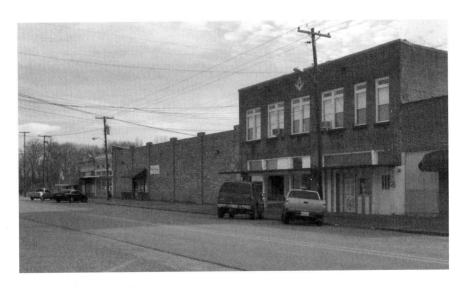

Main Street in downtown Goodman, Mississippi, January 2014. *Photo by Jennette Moore.*

time at Parchman Prison Farm, the state penitentiary in Drew, Mississippi, as a result of the shooting. So I decided to validate what they have believed for many years to be the truth.

I contacted the Mississippi Department of Corrections, Parchman location, to determine if Tillman did serve time in Drew, Mississippi, for the death of Marshal Moody. Archived records do not show that Tillman ever served time for the murder, if in fact, he was ever convicted of the crime. The archives did show that Tillman was incarcerated at the prison in the late 1920s. According to the records, Tillman was sentenced to the state prison farm on September 24, 1929, to serve a sentence of two years. But as previously noted, Tillman's sentence was for making moonshine and not for shooting the marshal.

Tillman's luck must have been running high, for he served only fifteen months of that two year sentence. According to an article published in Laurel, Mississippi's newspaper, the *Laurel Leader-Call*, "E.T.Branch" appeared on a lengthy list of individuals who were granted early prison releases in mid-December 1930, as part of former governor Theodore Bilbo's "Christmas Pardons and Suspensions." And by Christmas 1930, Tillman had returned to his native Attala County as a free man.

John Henry Lepard Remembers Tillman

When I asked Lepard if he personally knew Tillman, Lepard replied that he knew the man well. In fact, Lepard said, he is related to Tillman's last wife, Maxine Ables, through a connection to the Cotton family. Lepard described Tillman as a tall man, about six feet, who had dark hair and brown eyes. Lepard added that Tillman had a "mean look…a hard, solemn look" and that "he didn't laugh or smile much." When I asked for a more detailed physical description of Tillman, Lepard described him as a "big man with narrow shoulders,"a "big waist" and "wide hips." Although Tillman was a large man, Lepard added, he was never overweight. According to Lepard, Tillman was "neat and clean" in his appearance, with a "nice haircut" and always "clean-shaven." Tillman was known to "carry a pistol, a .38-caliber revolver, in the back of his belt," and he acted as if he "wanted most people to know that he was a bad man who didn't want people trifling with him." In fact, Lepard said he had "more than a few" conversations with Tillman at the club he operated near Goodman. When he was a young man, Lepard

said, he was employed as a driver by an older man named Jim Cotton. The sole responsibility of the job was to drive Mr. Cotton home from one of the local nightclubs where Cotton liked to drink and gamble on weekends. When I asked Lepard if Cotton ever got into trouble in the nightclubs he frequented, Lepard said Cotton was not a "rabble-rouser." He added that Cotton had defended himself on one occasion, after a man attempted to cut his throat. Cotton defended himself by hitting the man in the head with a few beer bottles, consequently killing him. Cotton was never prosecuted for the incident, since law enforcement authorities ruled that the man's death was "justifiable homicide." Lepard's job as Mr. Cotton's driver benefitted both men—Lepard earned some pocket money, and the intoxicated man arrived home safely with his car still intact at the end of the evening. According to Lepard, Cotton's favorite night spots were Mandy's Place, John Tye's Place and Tillman's clubs, including the store in Goodman and Tillman's place south of Goodman. The latter place, Lepard explained, was where "mostly blacks went."

While Cotton drank and gambled, Lepard waited inside the club, where he listened to music and watched folks dance until his employer was ready to leave. During visits to Tillman's place, Lepard related how the club owner often walked over and initiated conversations with Lepard. At this point in the conversation, Lepard added that if Tillman liked someone, he "would be nice to the person," but "if he did not like the individual, he didn't have anything to do with them." According to Lepard, the conversations primarily concerned Tillman's attempts to be a "matchmaker for Patty," one of his daughters, who Lepard recalled was quite pretty and close to his own age. During these talks, Tillman told young Lepard that he liked him because he "was not a drinker or a carouser" and that he wanted Lepard to date his daughter. Lepard replied that he knew Patty and considered her to be a friend, and Lepard added that he preferred to "keep it that way." Eventually, Tillman seemed to accept the young man's decision about dating his daughter and stopped his matchmaking attempts. A number of years later, John Henry Lepard met and married a young woman from another county, and Patty Branch married the man to whom she was still married when she died in December 2013. Interestingly, over a decade later, Lepard worked for a time at a Goodman liquor store owned by Tillman's widow.

Bessie and Tillman

While Tillman Branch served fifteen months in prison, Bessie Dickerson Branch was left to raise four young children, but when I searched for the whereabouts of Bessie and the children in 1930, my efforts were unsuccessful. According to one of the children, Bessie and her family moved into a small house Bessie's father, Jim Dickerson, owned on a large farm he operated in rural Attala County. Although Tillman did see his children from time to time after he was released from prison, contact seems to have been infrequent and for very short periods of time. One of Tillman's older sons recalls that he saw his father for the first time when he was about three years old, when Tillman stopped by to see his children after he had been released from prison around Christmas 1930. His son told how he was much too young to fully understand who Tillman was until much later when his family talked to him about the man who came to visit.

When I asked one of Tillman's older daughters what she remembers most about visits with her father, she replied that he always brought "little wrapped cakes and toothbrushes." When I asked her why he gave his children toothbrushes when he visited, she explained that "dental hygiene was something that was important to Daddy" and that he wanted his children to take care of their teeth. This same daughter added that she always loved her father, and she knew that he loved her very much, too. In a separate conversation, another daughter recalled that she did see her father, although it was not very often. She further related how difficult life in the 1930s was for her mother and her family as they tried to make a living on her maternal grandfather's farm. And she still remembers the long hours her mother worked in the fields, often with the children working by her side. She does not recall her family receiving much help from her father or from his relatives, although most of them lived nearby. She and her brother separately related how dedicated their mother was in caring for her children and making sure they had food to eat and clean clothes to wear to school and to church on Sunday. "Mama worked hard to take care of us," she said and added, "We had a good mother."

Tillman Marries Rosie

Although the dates of Tillman and Bessie's actual separation and later divorce are uncertain, they must have divorced either before or during Tillman's incarceration in Parchman, since Tillman married his second wife, Rosa Mae Langford, in Leflore County on March 28, 1931. Tillman's new wife was nineteen years old and had been living in adjacent Holmes County in the year that preceded their marriage. When Tillman and Rosa Mae Langford applied for a marriage license in Greenwood, Mississippi, on March 28, 1931, Tillman provided Nettie Branch as the name of his mother and Ben H. Branch, of Sidon, Mississippi, his eldest brother, as his "guardian." Rosa Mae Langford named Mrs. Willie Lee Langford of Durant, Mississippi, as her mother. The subsequent marriage record establishes that E.T. Branch and Rosa Mae Langford were married that same day in a ceremony conducted by Reverend J.R. Hughes of Greenwood, Mississippi. Prior to her marriage to Tillman Branch, Rosa Mae, twenty-four-year-old brother Edward Langford and their seventy-year-old father, Tom Langford, had been enumerated on the U.S. census of 1930 as residents in a Holmes County household that her sister, Annie Lee Langford Pettus, shared with her husband, Tom Pettus, and their two young daughters. Tom Pettus was a brother to my maternal great-grandfather, William Elza Pettus, and according to information contained in the census record, he had been married once before his current marriage to Annie Lee Langford, a woman who was young enough to be his daughter. According to family information, Tom Pettus, like so many other men in Holmes County in 1930, was a bootlegger.

Mae Bess Branch Hodges, one of Tillman's daughters from his marriage to Bessie Dickerson, told me that she never met the woman known as "Rosie," nor was she aware her father had ever legally married the woman. She had heard from others, however, who had seen her, that Rosie "had red hair." Based on this information, the second Mrs. Tillman Branch may have been the red-haired woman my father recalled seeing in the car with Tillman when he stopped off in Attala County to see his children, shortly after he was released from Parchman State Penitentiary around Christmas 1930. According to another of Tillman's daughters, Helen Branch Haffey, her father and Rosie "ran a business" near Lexington after he returned home from prison in December 1930.

Bessie Marries Jim Johnson

Bessie remarried, too, sometime prior to 1940. Bessie's remarriage was revealed during a review of the U.S. census conducted that year for Beat 4 of Attala County, where she was enumerated as "Bessie Johnston," a widow, with three children—Helen, Mae Bessie and Tillman Jr.—living in her household. Her eldest son, James Edward Branch, and his young wife, Linnie Mae McCrory, along with their one-year-old child, James, lived next door, in a house that once was occupied by my grandparents when they were first married. Although he was unsure of the exact date, one of Tillman's children from his marriage to Bessie recalled that his mother first remarried in the 1930s. Her new husband was Jim Johnson, the principal of Boyette Crossing School, a six-grade school located in Attala County, across the Big Black River from Goodman. This individual, as well as one of his sisters, recalled how their elder brother, James Edward, was unhappy with his mother's new husband and went to live with his father in Lexington for a few months after the marriage. Living with his father was a short adventure into adulthood for the teenager, however. Tillman had gotten James Edward hired on as a dump truck driver for his uncle's sand and gravel operation, and understandably, the long hours and grueling work were too much for the young man. It wasn't long before he returned home to live with his mother and siblings.

Apparently, Johnson and his stepchildren did not get along, and his relationship with Bessie and the children soon deteriorated. Even though the two older children's stories differ slightly about the exact reason for the breakup of their mother's marriage to Mr. Johnson, the relationship ultimately ended when Johnson accepted a position at a school in another state and left the household.

Bessie Marries for a Third Time

A decade or so later, Tillman's ex-wife, Bessie Dickerson Branch Johnson, married John C. McCrory of Attala County, who had been married to Mamie Branch, one of Tillman's sisters. Interestingly, the man that Tillman's four older children knew as "Uncle John" suddenly became their stepfather. As a result of this twist of fate, Bessie's children born during her marriage

to Tillman and John McCrory's children from his marriage to Tillman's sister Mamie were not just cousins but stepsiblings, as well. Bessie Dickerson Branch remained married to John McCrory until her death in 1977. She is buried in Seneasha Cemetery in Attala County.

7
THE DRY STATE OF MISSISSIPPI

There is no oral information or any written evidence that reveals exactly when Tillman began making moonshine. And there is no one living who is willing to guess who taught Tillman how to concoct the illegal and potent mix that some called the best moonshine in the country. Most likely, Tillman acquired his knowledge of moonshine making and the fast cash it could bring from neighbors, friends or even relatives. Mixing up a little moonshine for self-consumption and sharing it with others, after all, was a common practice in those days. Even before Prohibition began in 1920, after the ratification of the Eighteenth Amendment to the Constitution, the state of Mississippi had been dry since Edmond Favor Noel was governor in the early 1900s. In reality, however, moonshine and bootlegged liquor were available just about everywhere throughout the twentieth century, and it was no different in Holmes County, Mississippi. Of course, buying liquor of any kind depended on where a person lived and who that person knew. Corn whiskey, as well as illegally sold bonded liquor, could be purchased in all types of settings, ranging from the trunk of a car to a makeshift drive-in window in some out-of-the-way, seemingly abandoned motel. A number of places that fit the latter description could be found along what was called "the Gold Coast" in Jackson as late as the mid-1960s when I was in high school. Older residents who lived in Jackson, Mississippi, during those years will remember the location of "the Gold Coast" as one of the present-day roads in Rankin County that leads to Jackson's Medgar Evers International Airport. The fact that liquor was readily available, even though it was not

legal at the time, was recounted by Mississippi native son Willie Morris, a former editor of *Harper's* magazine in the 1960s. In his memoir, *North Toward Home*, Morris states:

> *Mississippi was a dry state, one of the last in America, but its dryness was merely academic, a gesture to the preachers and the churches. My father would say that the only difference between Mississippi and its neighbor Tennessee, which was wet, was that in Tennessee a man could not buy liquor on Sunday. The Mississippi bootleggers, who theoretically operated "grocery stores," with ten or twelve cans of sardines and a few boxes of crackers for sale, stayed open at all hours, and would sell to anyone regardless of age or race. My father could work himself into a mild frenzy talking about this state of affairs; Mississippi, he would say was the poorest state in the union, and in some ways the worst, and here it was depriving itself of tax money because the people who listened to the preachers did not have the common sense to understand what was going on.*

A Town Named Durant

Durant, Mississippi, situated on U.S. Highway 51 just north of Goodman, is a town that is rich in Mississippi history. Its namesake, a French Canadian trapper and trader named Louis Durant, is said to have traveled down the Mississippi River with his brother, Michael, and settled among the Choctaw about 1770–1775. Interestingly, historians relate how Durant brought several head of cattle with him and consequently introduced cattle raising to the Choctaw community. Soon after they arrived in the area, the men married Choctaw women and allegedly were adopted into the tribe.

As his land and his wealth grew, Durant built a home on a bluff that overlooked the Big Black River in a portion of Yazoo County that later became Holmes County. And it was in that bluff-top home that Durant and his wife, Shi Ne Yak, raised three sons—Pierre, Charles and Louis—and two daughters, Margaret and Syllan. During the War of 1812, Durant served under Pushmataha, the chief of the Choctaws, with Andrew Jackson at the Battle of New Orleans. When he returned home, Durant became known by his peers as "Captain Durant." As the population increased in

Crossroads sign on U.S. Highway 51, Main Street in Durant, Mississippi. *Author's photo collection.*

Oil-on-canvas mural in Durant, Mississippi post office. *Author's photo collection.*

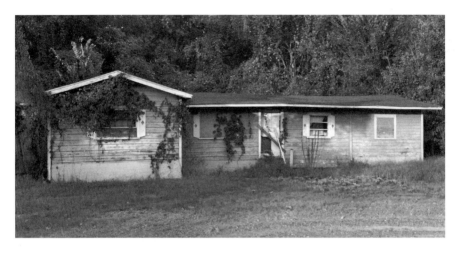

Original location for Tillman Branch's Blue Flame Café, Highway 12 East, near Big Black River Bridge. *Author's photo collection.*

the area across the Big Black River from Durant's home, surveyors laid out a new town they named in honor of Captain Durant. Less than two decades later, Pierre Durant, Captain Durant's son, would leave Mississippi with other Choctaw headed for the Oklahoma Territory. A few years later, a town named Durant, Oklahoma, named for Pierre's grandson, was established barely forty miles north of the Red River.

With its location at the crossroads of U.S. Highway 51 and State Highway 12, which runs between Lexington and Kosciusko, the population of Durant, Mississippi, grew rapidly after the railroad was built. During that same period, new railroad passenger service brought large numbers of visitors to town who vacationed at a popular hotel and resort known as Castallian Springs. In 1939, as part of former president Roosevelt's New Deal, a new U.S. post office was built by the Treasury Department on U.S. Highway 51, Durant's main thoroughfare. Inside the lobby of the Colonial Revival–style building, visitors can see the New Deal work of Pulitzer Prize–winning artist Isadore Toberoff, an oil-on-canvas mural entitled *Erosion, Reclamation and Conservation of the Soil*. And in 1940, Durant became the first home of the 4-H Club. Many years later, a 1962 article in *Sports Illustrated* entitled "The Sweet Music of the Hound," told the story of the U.S. Open in foxhunting, an event that was held in Durant. According to the extensive article, which included some amusing anecdotes about the Durant competition, 128 hounds were entered in the four-day event.

But Durant's real claim to fame must have been the dozens of nightspots that offered music, gambling and liquor and lined the highways in and around town. Old newspaper articles indicate that the establishments continued to grow and thrive over the years, in part due to the many railroad employees and highway construction crews that flooded the town. According to a conversation with longtime Durant resident Sonny McCrory, Tillman Branch operated one of the many nightspots that existed in or near Durant during the 1940s and 1950s. McCrory described how these clubs, twenty-seven in all, with names like White Pig, Green Lantern, Rainbow Garden, Club 13, Club 14 and Mile-a-way, were located along U.S. Highway 51 and Highway 12, an east–west route that connects Durant with Lexington and Kosciusko. Tillman's club, the Blue Flame Café, was located east of Durant, across the railroad tracks on the north side of Highway 12, just west of the Big Black River Bridge. To locals, the club was known simply as the Spot or Tillman's Place. The long wooden building that once was known as the Blue Flame Café is now abandoned, and it is currently painted blue.

A Dry State and a Wet County

Passed during the gubernatorial term of Holmes County native son Edmond Favor Noel, a Mississippi law made liquor illegal in 1907, and in 1908, the state legislature enacted it. Although the state was officially dry until 1966, when it became the last state to repeal Prohibition, enforcement of the dry law was left to the discretion of county law enforcement officials. In 1966, the first legal liquor store in Mississippi was opened in Greenville, a Mississippi River town located about halfway between Vicksburg and Clarksdale, Mississippi. The store was known as the Jigger and Jug, and it was owned and operated by the Azar brothers, members of a local Delta family.

During the period that began in 1908 and ended in 1966, when the sale of liquor became legal, Holmes County seemed to be Mississippi's epicenter of illegal liquor activity, and selling moonshine and bonded whiskey became an industry of its own, maybe one of the largest in the county. By the 1940s, according to historical Mississippi State Tax Commission documents, the sale of illegal liquor in Mississippi had become a multimillion dollar business. This rather large income stream produced no tax money, however, for a poor state that certainly could use the revenue. In 1944, the state of Mississippi decided to claim its share of the profits from liquor sales when

the legislature passed the so-called black market tax law. Some of those who questioned the law spoke out against it.

In an article written by Hazel Brannon Smith and published in the *Lexington Advertiser* the next year, Smith wrote "Holmes County whiskey dealers and bootleggers sold $241,888 worth of whiskey (wholesale price) during the last nine months, according to records in the State Tax Collector's Office." She continued, "This just doesn't make sense." And to further prove her point, Smith's article included copies of itemized statements showing total sales and taxes paid. Payments to the State Tax Collector's Office could be used to determine a dealer's business and personal income and, in some cases, the information submitted led to state and federal income tax investigations. In contrast to the rather large amount of money paid out by residents for whiskey, news articles in the *Lexington Advertiser* revealed Holmes County's quota for war bond sales in 1945 totaled only $2,500, and in 1946, the county's Red Cross quota amounted to $5,200.

Although the details are unclear, in later years, Tillman Branch became the subject of several tax investigations, both state and federal, and according to one of his children, the man some have called one of Holmes County's best-known bootleggers paid over $50,000 in fines. Apparently, Tillman Branch also may have been one of Holmes County's wealthiest bootleggers.

Hard Times and Hard Liquor

During the fifty-eight-year period between 1908 and 1966, the sale of illegal liquor, alcohol consumption and the activities that surrounded both created an alcohol-fueled counterculture that left crime and corruption in its wake. And the deep and lasting impact on everyday society in Tillman Branch's native Attala County and in Holmes County, where he operated several nightclubs, was extensive. The same was true of many other places in the state where the impacts, physical and societal, were all-too familiar. A review of mortality figures during the early 1900s shows that large numbers of men, and women as well, died from the systemic effects of alcohol consumption or from crimes that were committed while under the influence of alcohol. According to a close family member, Tillman Branch's older brother Frederick Mabry "Doc" Branch was one of those who suffered an alcohol-related death, when he died from drowning after he fell into a ditch of water while drunk. In addition to adverse health effects and sometimes death,

excessive alcohol use became a leading factor in the loss of employment and a contributing factor in the breakup of marriages that so often undermined the structure of the family.

In the years immediately after the Depression, tremendous numbers of people lost their money, their homes and their land and were forced to live in dire circumstances that previously would not have been imaginable. As unemployment loomed in the United States in general, rural counties in the South were hit hard. And Holmes and Attala Counties were no different. As hard times unfolded and the availability of jobs was at a record low, some men who apparently were unafraid of societal or legal consequences, like Tillman Branch, turned to making moonshine and selling it as a business. Not only did the business produce a steady stream of cash, but it also had a following of repeat customers. Alcohol provided not only income to those who made and sold it but also comfort to those who wanted to escape the realities of a severe financial depression and the economic and social devastation left in its aftermath. As people who had lost most of what they had ever owned contemplated where to go and what to do next, alcohol consumption increased, and the sale of illegal liquor boomed.

Liquor and Law Enforcement

When Walter J. Murtagh was elected to the office of Holmes County sheriff, *Durant News* owner and editor, Hazel Brannon, wrote the county was "on the verge of disaster." But the editor and many of those who voted for Murtagh believed the well-known and respected owner of a Ford dealership in Pickens, Mississippi, would live up to his campaign promise to rid the county of its corrupt activities. Soon after Murtagh's election in 1944, however, it became apparent that most of the sheriff's campaign promises had been lip service only. Bootlegging continued to thrive, and corruption, murder and mayhem became a way of life in the small and primarily rural county.

Richard F. Byrd, owner of a Lexington Chevrolet dealership, was later elected sheriff, and those who wanted Holmes County's criminal activities to cease had faith that the former scoutmaster would clean up the county. One of his campaign slogans was "Just ask the Boy Scouts about me." At first, Byrd made good on his promise to stop the flow of whiskey in Holmes County, and those who wanted law and order in the county believed change was on the way. But soon after Byrd shut down some of the bootleggers, a

cluster of new businesses sprang up in Holmes County, with much of the illegal liquor supplied by one of Byrd's friends, a Tchula, Mississippi man named Bluford Taylor. One of Bluford's brothers, Percy Paul Taylor, married my mother's first cousin Allene Wallis. Later, Allene became a widow when a black man shot and killed her husband during an apparent robbery at his liquor store in Tchula. Sheriff Byrd's term became plagued with another problem that was much bigger than the illegal liquor business that saturated Holmes County: the U.S. Supreme Court decision in 1954 that mandated desegregation of public schools.

Hazel Brannon Smith and others who crusaded against corruption again saw an opportunity for change in Holmes County when Andrew Smith was elected in 1956 to succeed Sheriff Byrd. In 1960, Smith was succeeded by his wife, Hattie Coleman Cade Smith, known as "Hab," who served as sheriff of Holmes County for two terms, while her husband served as chief deputy. And Andrew Smith succeeded his wife, when he was elected as sheriff for a second term. All total, Andrew Smith and his wife served as sheriffs of Holmes County from 1956 until 1968, a time period that spanned twelve years. When Andrew Smith initially campaigned for the office of Holmes County sheriff, he promised, just like his predecessors, that he was the man who would put the bootleggers and their corrupt cronies out of business. And in the case of at least one bootlegger and nightclub owner, Tillman Branch, Andrew Smith strongly intended to keep his promise.

The Sheriff Gets Tough on Tillman

By most accounts, Tillman did not involve his children in his business activities. But according to at least one individual, he did ask one of his sons sometime in 1956 to convey a message to newly elected Holmes County sheriff Andrew Smith. As the sheriff was elected on a platform to clean up corruption in Holmes County, Tillman must have known that protection for his whiskey dealings had ended when Sheriff Murtagh left office. Tillman's question for Andrew Smith was something to the effect of "How much will it take to keep you out of my business?" Smith's answer was that he was not for sale. He recommended that Tillman get out of the bootlegging business and earn a living like other law-abiding citizens: raise crops and cattle, sell pulpwood and use his money wisely. Tillman got mad, but the sheriff took action. According to the individual who related the story, Sheriff Smith

waged an all-out war against Tillman and a few others in Holmes County. Smith raided Tillman's businesses and filed charges that kept Tillman in court, causing him to pay heavy fines. Allegedly, Smith also turned Tillman in to the Internal Revenue Service, federal and state, an act that caused Tillman to pay over $50,000 in fines alone. For Tillman at least, it wasn't easy to be a bootlegger during those years, and it was also expensive.

According to an elderly black man from Pickens, Mississippi, named Andrew Lemon, the animosity between Tillman and Sheriff Andrew Smith reached an all-time high in the late 1950s. Lemon, who was employed as the longtime driver for one of Tillman's acquaintances, recalled his boss's version of one of the more serious incidents involving the nightclub owner and the sheriff. Apparently, Sheriff Smith had refused to renew Tillman's liquor license, a requirement that sounds almost unreal in a state during a time when buying or selling liquor of any type was illegal. According to Lemon, Tillman drove over to Lexington, the county seat of Holmes County, to ask Sheriff Smith in person to explain why he had refused to renew his license. As Lemon's story goes, Tillman walked into the sheriff's office and stood in front of his desk, where the sheriff remained seated, and proceeded to ask why the law man had not renewed his license. The sheriff told Tillman that he did not renew the liquor license because he had heard through his sources that Tillman had hired some "Italians from Chicago to come down here and kill [him]." Tillman quickly and loudly replied, "That's a lie! If I wanted to kill you, I would do it with your own .45 right here and now!" After a very pregnant pause, and with Tillman still standing over the sheriff, staring angrily straight down into his eyes, Sheriff Smith agreed to renew Tillman's license. And the Blue Flame continued to operate as usual.

The Long Branch

In the 1950s and early 1960s, in addition to the nightclub south of town, Tillman owned and operated a store just outside the Goodman city limits that was very similar to the grocery stores Willie Morris described in his book. Called the Long Branch, or simply Branch's Store, the one-story structure included living quarters for Tillman and Maxine and their three children. The building had a plate-glass window in front and was painted white. I remember how the store looked, since I saw it many times as a child and a young teen when we visited relatives in Goodman or in Attala County.

The parking lot was made from loose gravel, like the material used to pave some of the country roads in rural parts of the county, and it had gas pumps out front. The store's location just off U.S. Highway 51, the major route between Jackson and Memphis in those days, provided easy access to locals and to travelers who wanted to stop and buy limited food items or beer. According to a few older individuals who were willing to admit they had been to the Long Branch, the store sold small grocery items, snack foods and soft drinks. In addition, the establishment contained a few tables and chairs and a pool table, where locals congregated on Saturday night. Although some who remember the Long Branch recall that the bestselling item in the store may have been the moonshine that Tillman sold by the bottle from the back room, others believe it could have been the entertainment one might experience in the trailer with bars on its windows that sat across the highway.

According to a few older local residents of the Goodman area who were willing to talk to me but who were unwilling to have their names published in this book, Tillman's "maids," including Clytee Parks and another woman named Mildred, lived in the trailer across the highway from the Long Branch. Those who knew Clytee told me she also worked down at the Blue Flame, where club patrons often saw her working beside Tillman at the counter. One older man who knew Clytee fairly well described her as a "smart, good looking chocolate-colored woman" who helped Tillman "run things down at the club."

8
THE BLUE FLAME

In addition to being the proprietor of the Long Branch—or Branch's Store, as it was referred to by most folks—on U.S. Highway 51 south of Goodman, Mississippi, Tillman, at one time, had operated as many as four nightclubs in Holmes County, including the Blue Flame Café east of Durant and the Blue Flame II, located about a mile and a half south of Goodman. Known by locals as Tillman's Place, things that went on down at the Blue Flame south of Goodman, as well as others like it, seemed to be just outside the long arm of the law. Tillman's Place was what many called a "honkytonk" or a "juke joint," commonly referred to as a "juke." The latter term, "juke," is said to be derived from the Gullah word , meaning rowdy or disorderly. And without question, the Blue Flame could get pretty rowdy and disorderly, especially after dark on Saturday nights.

In their book entitled *Alcohol and Intemperence in Modern History: A Global Encyclopedia*, Jack Snead Blocker, David M. Fahey and Ian R. Tyrell include a section about juke joints written by Kevin Grace. In this section, Grace relates how "blues music…was the impetus to bringing in customers to the juke joints." He references interviews with Muddy Waters over the course of his career, a musician who got his start near Stovall Plantation south of Clarksdale, Mississippi. According to Grace, Waters often described how "Bootleggers would hear of a singer or musician and hire them to play, knowing the music would entice patrons to drink and dance…bootleggers would string lights in trees" with "the lights" serving as "a beacon to the locals." Grace continued to say that "dice games and other gambling went

on outside." The description of a juke joint provided in the encyclopedia most accurately depicts Tillman's place known as the Blue Flame, at least according to two people who still remember how it looked.

In his 2007 book, *One Night of Madness*, Attala County native son and author Stokes McMillan tells the story of a white ex-convict named Leon Turner and how he brutally murdered a black family in 1950 in Attala County. After Turner was released from prison, and before he went on the killing spree that sent him back to Parchman State Penitentiary, he worked for a time making moonshine on "halves" for Tillman Branch to sell at the Blue Flame Café east of Durant. According to McMillan, Turner's working relationship with Tillman soon turned sour. Instead of terminating Turner's employment, an event that most certainly would have caused a physical altercation between the two men, Tillman simply told the local sheriff where he could find Turner tending the still. The sheriff acted on Tillman's tip and arrested Turner, an action that not only severed Turner's business ties with Tillman but also sent Turner straight back to Parchman. McMillan's book further mentions Tillman Branch in an excerpt from a story of the life of HoneyBoy Edwards. In his autobiography, entitled *The World Don't Owe Me Nothing*, Edwards wrote this about Branch:

> *Tillman Branch was ten years older than Leon. Born to a prominent Attala County Beat 4 family, he was a big, mean fellow rumored to have been involved in moonshining, prostitution, bribery, and bootlegging. He had killed at least two men through the years and had served time in the state prison. Twice married to white women, Tillman also kept black mistresses in a house trailer off Highway 51 near Goodman. One of the wives, fed up with these extramarital affairs, kidnapped her husband's favorite black mistress and sent her packing to Detroit. Tillman found his lover and returned her to the trailer. Beneath his unsavory aspects, Branch was a keen businessman. His most lucrative business was located just south of Goodman city limits, where Tillman owned one of the most popular juke joints around.*

By most accounts, including one by McMillan based on interviews with locals who had personal knowledge of Tillman's club, the Blue Flame Café was "unruly" and "disorderly" and was the scene of "unrestrained debauchery." Other clubs could not compare to the "uninhibited wildness," since "the Blue Flame had it all: boozing, dancing, fighting, gambling, cockfighting—and an occasional shooting to keep things lively."

McMillan's contacts also told that moonshine served in the club came from Tillman's several stills that he often hired others to operate and protect, as in the case of the man named Leon Turner mentioned earlier. Allegedly, Tillman was the only white person in the place, and he ran the bar himself. It sounds as if Tillman poured all the drinks, just in case someone got heavy handed, an act that would have cut into his very lucrative profits. According to at least one of McMillan's interviewees, Bailey Hutchinson, a man who is now deceased, Tillman knew how to settle disagreements when things got out of control down at the Blue Flame. Hutchinson told McMillan that Tillman kept a little snub-nosed .32-caliber pistol nearby just for that purpose. The gun was damaged, he said, because it was used for "pistol whippings of unruly patrons."

Early on Christmas morning 1958, things did get out of control at the Blue Flame south of Goodman. But Tillman was not the one who used a gun. According to news reports published in the December 27, 1958 edition of the *Jackson Daily News* and the *Durant News* on January 1, 1959, Thomas C. "Bo" Roby, a local black man, deliberately shot Tillman and two employees. No one was killed in the incident, but all three victims were taken to the community hospital in Durant, Mississippi, where they were treated and later released. The *Durant News* reported the following:

Goodman Café Owner Wounded by Shotgun

E.T. Branch, proprietor of the Blue Flame Café near Goodman, suffered wounds from a shotgun blast in the early hours of Christmas Day, and was taken to the District Two Community Hospital in Durant. Branch was shot by Thomas C. Roby, Negro, who was ordered to leave the café. Roby, who is a resident of Attala County, returned a little later with a shotgun. Aiming through the glass door, he shot the proprietor, with about 42 shots going in the face and neck and two penetrating the chest, according to Sheriff Andrew Smith. The shooting occurred about 3 a.m. Clytee Parks, Negro cook, and John Henry Barnes, Negro counter man, were injured by the same blasts, according to reports. Clytee received eighteen shots through the mouth and arm and John Henry received seven shots around the shoulder blade. Both were treated at the hospital in Durant after which they went home. Last reports were that Mr. Branch is recovering satisfactorily at home where he was moved Sunday night from the hospital. The Negro is still being sought.

Playing the Blues Down at the Blue Flame

Legends abound within the blues music community that a few musicians who later became famous may have gotten their starts playing the slide guitar, the harmonica, and singing the Delta blues in Tillman's club. Among those who allegedly entertained club patrons with sad songs of lost hope, love and betrayal was Elmore James of Lexington and a harmonica-playing Tallahatchie County native named Aleck Miller . Elmore's impact on rock 'n' roll was a strong one, with musicians like Jimi Hendrix and the Allman Brothers covering his songs. Other musicians, including B.B. King, Eric Clapton and John Mayall all have claimed that James influenced their music styles. Aleck Miller, better known as Sonny Boy Williamson II, was elected to the Blues Hall of Fame in 1980, about fifteen years after he died in Helena, Arkansas.

One source of this information is a self-described cultural anthropologist, John L. Doughty Jr., whose hobby involves visiting and writing about Mississippi Delta juke joints, past and present. Originally from Tullos, Louisiana, Doughty maintains a website at www.deltablues.net called Junior's Juke Joint. Doughty has written on his website that he met "a woman from Lexington" during one of his blues excursions into Holmes County, Mississippi, who told him a story about a place that sounds very much like Tillman's. Doughty recounted how the woman said there was a "long-gone juke joint in the woods between Durant and Goodman," where "she remembered her daddy coming home from work all excited about Elmore James and Sonny Boy Williamson playing together there that night." Often, Doughty posts photographs of the people he meets in the places he visits, and several years ago, he posted a photo of what he believed at the time to be the remains of Tillman's place south of Goodman, Mississippi. It seems that some legends don't die.

9
TILLMAN THE TOUGH GUY

After his early conviction and imprisonment for "manufacturing liquor" in 1929 and the death of James Robert Moody, Goodman's town marshal, Tillman had garnered quite a reputation for being a tough guy. He was a tall, big man who was known to carry a gun, and his temperament was such that he didn't back down when he was challenged to a fight. One elderly man who grew up near Tillman recounted meeting him for the first time soon after Tillman was released from prison in December 1930. According to this individual, Tillman had driven over to Attala County to see his children by Bessie Dickerson, and the man saw Tillman when Tillman parked his car near the man's house. This individual was still a young boy at the time he first saw Tillman, but he distinctly remembers that Tillman arrived in a shiny automobile with a good-looking redhead sitting beside him that he said he had met in Greenwood, Mississippi. This same individual described Tillman as a "big man," with "light brown hair,"who stood about six feet, three inches and weighed about two hundred pounds. He went on to say that Tillman, whom he continued to see again from time to time throughout Tillman's lifetime, was a "neat man…his hair was always combed" and that he was a "good dresser"who was not seen in public in anything other than "dress clothes." Maybe Tillman was just a man who was concerned about his outward appearance and the image he presented to others, but this gentleman's description of Tillman indicates he may indeed have been the "ladies' man" that local rumors have long alleged. Another individual, one who grew up in Attala County not too far from where

Tillman lived, remembers how Tillman narrowly escaped another arrest for bootlegging not too long after he was released from prison. According to the contact, neighbors and relatives helped Tillman leave Attala County on a little-known back road that ran through dense woods on private land, an effort that allowed him to escape into an adjacent county and out of the jurisdiction of local law enforcement officials.

The Visitor from Vegas

Someone who remembers Tillman well, but who has asked that his name be omitted from this book, told the story of a man who paid Tillman an unexpected visit at Tillman's club south of Goodman. The identity of the man and the timeframe of the visit remain unclear. As the story goes, a stranger who drove a big black Cadillac and who wore a shiny gabardine suit swaggered in the door of Tillman's club one afternoon. The man looked Tillman in the eye and promptly told him he was from Las Vegas and was sent to give him a "good beating." Tillman muttered something to the effect of "Is that so?" and proceeded to come out from behind the counter.

As Tillman walked toward him, the man removed his suit jacket in preparation of a fight. Tillman and the man in the suit, without any further words, faced off with their fists poised, and the battle began. Apparently, the man from Las Vegas was no match for someone like Tillman, a big man who feared no one. When the man found himself pinned underneath Tillman, his body beaten and his face against the dirty floor, he may have wished that he had brought help. And more than likely, thoughts flashed through his head that he might never see Las Vegas again. So the man pleaded with Tillman to stop beating him, and Tillman complied. After Tillman let go, the man scrambled to his feet and grabbed the jacket he had hung on the back of a chair. The two men quickly shook hands, and the man from Las Vegas headed for his Cadillac. Proud of the way this unexpected encounter had turned out, Tillman wiped his hands and poured himself a drink of cold water. And the man who had driven cross-country to beat Tillman to a pulp was staring in his rearview mirror as he raced up U.S. Highway 51, driving north out of Holmes County as fast as he could.

No one knows for sure, but speculation is the unidentified man from Las Vegas may have had ties to the New Orleans mafia headed by crime boss Carlos Marcello. Allegedly, Marcello was tied in to mobster Meyer Lansky

in Las Vegas, who was allowing Marcello to skim off the profits of some of his casinos in return for protection. Some years later, Marcello and his operations, which included illegal gambling and slot machines, came under close federal scrutiny, and J. Edgar Hoover unsuccessfully attempted to deport him. Supposedly, slot machines present in businesses in Delta towns up and down U.S. Highway 61 that ran south to Baton Rouge and New Orleans were placed there by members of Marcello's network operating out of Louisiana. According to conversations I had with my grandfather before he died, slot machines existed in the back rooms of otherwise legitimate businesses in and around Indianola, Inverness, Isola and Belzoni as late as the 1950s. The purpose of sending someone to beat up Tillman may have been to scare him into turning over some of the action going on at his club to the big boys. But neither the Cadillac nor the man in the shiny suit returned, and apparently, Tillman wasn't forced to share his profits.

TAL ABLES

Tillman seemed to take no guff from anyone, even his in-laws, especially when one of them had hurt his family. According to several older family members who remember the incident when it took place, Tillman was threatened by his third wife's cousin, thirty-four year old Walter Talmadge "Tal" Ables, after he had been banned from Tillman's place for injuring one of Tillman's nephews—Hoye Branch, Doc Branch's son—with a knife. The knifing incident was serious enough that it required young Hoye to spend a week of his military leave in a local hospital. Apparently, Tal Ables held a grudge for being banned from Tillman's club and decided to seek revenge by shooting Tillman. According to a relative's account of the event, Tillman had just closed his place in Goodman at about 2:00 a.m. on November 26, 1944, the Sunday morning after Thanksgiving, when Anthony Smith, a black friend, knocked loudly on the door. When Tillman answered the door, Smith told Tillman that Ables was hanging around outside the place and had said that he intended to shoot Tillman. When Tillman walked outside to take a look, Ables had already left and was walking down the street toward downtown Goodman.

As the story goes, Tillman got in his truck and drove around the block until he saw his cousin-in-law walking toward a streetlight. As Tal Ables walked

under the light, Tillman drove up beside him. As soon as Ables saw Tillman, he raised his shotgun to shoot. But before he could pull the trigger, Tillman shot the man five times with his .45 revolver, and Ables fell dead beside the street. At that point, Tillman got out of his truck and walked across the street to my great-aunt Stella Branch Young's residence, where she was standing on the porch after being awakened by the gunshots. Tillman asked Aunt Stella, his cousin, to call the sheriff and to tell him he had shot and killed Tal Ables. Tillman added that Aunt Stella should tell the sheriff that he had gotten his socks wet and that he was going back home to change them and would wait for the sheriff there. Tillman was taken to jail, where he posted bond, but the charges were dropped at a preliminary hearing. Walter Talmadge Ables, thirty-four years old at the time he died, was buried in Seneasha Cemetery near other Ables relatives and in proximity to Tillman's parents and some of his other relatives.

At this point, some who knew him began to wonder if Tillman actually led a charmed life.

Money by the Bagful

Any number of other Tillman stories are still being told in the counties where he lived and where he made a living. Among these stories is one that indicates Tillman's profits from his business activities may have been large enough to warrant the visit from the man from Las Vegas. The story was told by a longtime Attala County businessman, a distant relative of Tillman, who heard the story from his father. According to the man's father, he saw Tillman every Monday morning when each of the men went to the bank to make a deposit. But unlike other merchants and businessmen in the area, Tillman transported his weekly earnings in large brown grocery sacks. The man added that his father said the grocery sacks always appeared to be full of cash. Another story, related by a close family relative who was present when it happened, adds particular significance to the first story about the bags of money. According to the account, managers of Tillman's four nightclubs arrived at the Long Branch early on Sunday morning, and all of them carried large sacks of money. Apparently the men were there to settle up with Tillman after a lucrative Saturday night. At least one of these men may have been Sam Henry, who was married to my maternal great-grandmother, Lucy Lula Trigleth Pettus Henry. According to my mother,

Eagle's Nest near Durant, Mississippi, as it appeared in late 2013. Alleged one-time distribution center of Tillman Branch's bootlegging operation in Holmes County. *Branch family photo collection.*

Sam Henry managed the Eagle's Nest, a popular Holmes County nightspot. Allegedly, at one time, the Eagle's Nest was the center of Tillman's local bootlegging operation.

THE TALE OF JOHNNY HOLMES

More often than not, Tillman came out on top when fighting was involved. But on Sunday afternoon, October 28, 1956, it sounds as if Tillman almost met his match. It seems that he and one of his black employees, Johnny Holmes, didn't see eye to eye about something that happened at the Blue Flame, where Holmes was working that day. According to a story related by an older relative and confirmed by a news article that appeared in a local paper, Tillman attempted to pistol-whip Johnny Holmes to get him in line. But Holmes was ill-tempered and strong, and after he took Tillman's gun away from him, Holmes shot Tillman in the shoulder and ran away. Witnesses said Holmes headed for Big Black River Swamp, a dense, dark and murky place where wild animals roamed and a man might disappear for weeks at the time, at least if he could survive the elements.

The Holmes County sheriff was notified, and Tillman was taken to the hospital in Durant, where he was treated and released. The sheriff and his deputies called Parchman State Penitentiary for help in finding Holmes, who was believed to be hiding out in the swamp. At the sheriff's request, authorities at the state prison sent out a pack of bloodhounds commandeered by the prison's well-known dog handler, Hogjaw Mullen, and the team of dogs quickly picked up a trail. Mullen and his dogs had been used in numerous manhunt situations throughout the state, including one in which they searched for infamous murderer Leon Turner in neighboring Attala County, so they were familiar with the territory. But this time, Mullen and his dogs returned from the search empty-handed.

Several days later, however, Johnny Holmes turned himself in at the sheriff's office in Lexington, most likely because he believed he would be safer in jail than hiding out in the woods, where he might be found and killed. A trial was held, and the judge ruled the shooting was accidental. The judge's rationale was that Holmes was only attempting to defend himself from the pistol-whipping initiated by Tillman. Interestingly, but not surprisingly, no charges were filed against Tillman.

On Trial in Lexington

Although my mother married one of Tillman's cousins, she recalled seeing Tillman only once, when she was a student at Lexington High School and was on her way to lunch downtown. She had heard news around town that Tillman had to appear in court at the Holmes County Courthouse for some charge that had to do with illegal liquor. And like several of the individuals I interviewed during the course of this book, others who lived in Lexington during the 1940s, my mother told me that Tillman's illegal activities were chronicled frequently in the local newspaper, the *Lexington Advertiser*. Apparently, these news articles about Tillman had contributed to his local notoriety as a bootlegger, and my mother readily recognized him as he crossed the street from the courthouse, headed to Diamond's Café, probably on his way to lunch. According to her recollection, Tillman was a "tall, strong-looking man with dark hair, and he was wearing a nice suit." It seems the man who was feared by so many other men always seemed to impress the ladies—my mother included.

Tillman and Federal Prison

During the course of research for this book, several Branch family members told me that Tillman Branch was charged and convicted of engaging in activities related to the manufacture and sale of illegal liquor in Holmes County and that he served time in the Atlanta Federal Penitentiary as a result of the activities. Research for this book confirmed that Tillman, in fact, was incarcerated twice in the federal prison in Atlanta, Georgia, and that he served each sentence prior to 1941. On July 2013, I submitted an electronic Freedom of Information Act (FOIA) request to the U.S. Department of Justice, Federal Bureau of Prisons in Washington, D.C., and on September 10, 2013, I received a letter of response from the Bureau's Office of the General Counsel. The response included the following details about Tillman's imprisonment in federal facilities:

Name: E. Tillman Branch
True Name: Edward Tillman Branch
Offense: Violation of National Prohibition Act
Sentence: 1 year
Federal Court: Northern District of Mississippi-Clarksdale
Sentencing Date: 10-24-32
Commitment Date: 10-30-32 to USP Atlanta, Georgia
Transfer: 12-8-32 to Federal Prison Camp, Fort Eustis, Virginia
Transfer: 1-2-33 to Federal Prison Camp, Fort Bragg
Parole Date: 2-23-34
Discharged from Supervision: 10-23-34

Name: Edward Tillman Branch
Offense: Violation of Internal Revenue Liquor Laws—Possession and Concealing Liquor
Sentence: 5 years and $3,000 fine
Federal Court: Southern District of Mississippi-Jackson
Sentencing Date: 11-7-36
Commitment Date: 11-14-36 to USP Atlanta, Georgia
Conditional Release: 4-13-40

10

TILLMAN AND MAXINE

By mid-1940s, Tillman and Rosie were no longer together, and he had remarried, this time to Maxine Ables, a young woman who was twenty-two years his junior. Maxine was the daughter of longtime Attala County residents William Chester "Billy" Ables, a farmer, and his wife, Myrtle Criswell Ables. The first time that Maxine appeared on a U.S. census record was in May 1930, when she was enumerated in the household of her parents, William and Myrtle Ables, who lived on the Goodman Highway. At seven years old, Maxine was the youngest of seven children living with their parents. By 1940, when the census was recorded again, Maxine was sixteen years old and lived with her widowed mother in the Newport community. In addition to Myrtle and Maxine, the household included four younger children, all born before William C. Ables died on May 7, 1939. According to a cousin of mine who is married to one of Maxine's brothers, Billy Ables was killed by a black man during an attempted break-in at a retail establishment in downtown Goodman, where Ables was employed as a night watchman. Information available on the U.S. census of 1940 recorded for Attala County, Mississippi, indicates that Maxine had completed the seventh grade. As the oldest daughter in a household headed by a widowed mother, Maxine was a very good candidate for an early marriage.

Details about how Tillman and Maxine met are unclear. Since the two individuals lived close to each other in rural Attala County, it seems likely they met simply because they were neighbors and each of them was unattached. Most likely, Tillman was attracted to Maxine because she was

young and pretty, with blond hair and blue eyes. And even more likely is that Maxine saw in Tillman the maturity and worldliness that may have been absent in young men closer to her age. One can only wonder if Maxine knew Tillman's background and reputation—that he was a bootlegger who ran some nightclubs and had served time in prison for violation of liquor laws. But in a small farming community like Newport, where families often were interrelated and everyone knew practically everything about each other, it seems almost certain that Maxine (and her mother) would have known Tillman's background before she married him.

Tillman and Maxine were married in Pickens, Holmes County, on July 20, 1940, by Justice of the Peace W.L. Arnold, barely three months after Tillman received a "conditional release" from federal prison in Atlanta, Georgia. Details of the "conditional release" were not available in the Federal Bureau of Prison documents I received as a result of the Freedom of Information Act request. A little over two years after Tillman married Maxine, he enlisted in the U.S. Army at Camp Shelby near Hattiesburg, Mississippi. According to his military record, Tillman was a resident of Holmes County when he entered the service on October 15, 1942, using his full name, Edward Tillman Branch Sr., on his enlistment papers. Most likely, Tillman added the suffix of "Sr." to distinguish himself from his fourteen-year-old son from his first marriage, who had the same name. Personal details, provided by Tillman at the time he enlisted, show that he had completed four years of high school and had been employed in a civil occupational category entitled "hotel and restaurant managers." The latter bit of information indicates Tillman likely owned at least one restaurant, café or nightclub before he enlisted in the service. The enlistment record also contained information about Tillman's height and weight, stating that he was six feet tall and weighed 207 pounds at the time he was inducted into the U.S. Army.

By the time Tillman enlisted in the military, his children by Bessie Dickerson were almost grown, and at least one of them, oldest son, James Edward, and his wife, Linnie Mae McCrory Branch, already had a child. Mae Bess married Sam Francis Hodges Jr., and her sister, Helen, married Thomas E. Haffey, a Holmes County man who grew up near Ebenezer. Tillman's younger son, Edward Tillman Branch Jr., known throughout his life as Tillman Jr., married a woman named Rose Mahan, whom he met in Alabama while working for the railroad. Tillman Jr. and Rose returned to Mississippi for a few years, living near Vicksburg and Durant, before they settled in Pascagoula, Mississippi, and raised five children, including a set of twins.

Gravestones of Maxine Ables Branch and daughter Joyce Dean Branch Woods, one of three children born during Maxine's marriage to Tillman Branch. *Author's photo collection.*

By the late 1940s, Maxine and Tillman had three children: a daughter named Patty Branch, born on November 15, 1944, her father's birthday; a son, Jimmy Dale Branch, born 1946; and Joyce Dean Branch, another daughter born two years after her brother.

Maxine Ables Branch continued to live in the Goodman area until her death on May 20, 1983. She was not buried in Seneasha Cemetery beside her late husband but instead was buried in Hillcrest Cemetery in Goodman next to her daughter Joyce Dean Branch Woods, who died unexpectedly after surgery when she was twenty-four years old.

At the time I began writing this book, five of Tillman's seven children—Helen Branch Haffey, Mae Bess Branch Hodges, Edward Tillman Branch Jr., Patty Branch Wigginton and Jimmy Dale "Jim" Branch—were still living. Although I contacted four of Tillman's children, only three of them were willing to share information about their father for this book. One of Tillman's daughters with Maxine Ables, Patty Branch Wigginton, politely declined to provide any information at all, stating that she had been "burned" when she provided information about her father for a book someone wrote a few years ago about Leon Turner. Sadly, Patty died on December 5, 2013, just a few

weeks before the book went to press. Jim Dale Branch, Patty's brother, was willing to talk to me, however, and he generously offered much insight into Tillman's family life and his relationships with his children.

11
BIG JIM TALKS

According to Tillman's youngest son, Jim Dale Branch, known to most friends and business associates as "Big Jim," Maxine and Tillman lived together until his father died in 1963, either on land his father owned in Holmes County or in living quarters attached to the Long Branch in Goodman. Jim remembers his mother and daddy as loving and caring parents who protected him and his sisters. Although Jim knew that his daddy owned and operated at least one nightclub, he believes his parents shielded him from the day-to-day details of his father's businesses. According to Jim, neither he nor any of Tillman's other children were ever actively involved in his father's moonshine-making, gambling or bootlegging activities.

Jim, however, did bring up the subject of his father's alleged interracial and extramarital affairs with women who worked for him, saying the rumors were untrue. But Jim went on to say that his father did have a close, personal and fairly long-term relationship with one of the women who cared for his children, a light-skinned woman named Clytee Parks, who had no children of her own. Jim explained that his father hired local black women to take care of his three children with Maxine when they were young and in school. He further explained that each child was assigned a separate caregiver, a woman who cared only for that child. Jim recalled there were other women who worked in the household, too, but Clytee was the only one who knew how to drive a car. And it was Clytee who Jim remembers driving him to school each morning.

Jim remembers his father as a kind and generous man who regularly gave him a sizeable allowance. As Jim recalls, Tillman handed him one hundred

dollars in cash each Sunday morning. If Jim were still asleep, his father left the cash on his nightstand. When asked how he spent this rather large allowance, Jim explained that he used some of it to buy shotgun shells for squirrel hunting but that he spent "most of it on chickens" that he raised for fighting. He remembers how his father often took him squirrel hunting, and he encouraged Jim's hobby of raising prize-winning chickens. Jim's voice seemed to glow with pride when he related how one of the chickens he bred was named a "grand national champion." As Jim recalls in hindsight, his father went out of his way to protect his children from the not-so-legitimate business that went on every evening at Tillman's nightspot. According to Jim and probably unknown by many who knew his father's reputation and how he made a living, Tillman was a diabetic. Jim recalls how his father's illness required him to test his urine daily in order to know how much insulin he needed to inject. Ironically, the man who made and sold liquor for a living couldn't drink. Jim recalled that he saw his father infrequently drink a few cans of beer, most often on holidays or other special occasions. But he never saw Tillman drink moonshine or hard liquor.

Jim feels that he grew up with many advantages that other children he knew did not have, at least before his daddy died, especially when there seemed to be an almost unlimited supply of cash. He recalls that he had everything he needed and most of what he wanted, including parents, sisters and other relatives who loved him very much. Jim told me how proud he was that his sister Joyce went to Delta State Teacher's College (now Delta State University) in Cleveland, Mississippi, to become a teacher, as she had always wanted. Jim explained that two of his ex-wives were teachers and that teaching is a profession he truly respects. He spoke with pride and apparent love about his two adult daughters, who were born during his first marriage. He also spoke proudly about his grandchildren, recalling all of their birthdays and their likes and dislikes, a strong indication to me that he dotes on them all. And Jim seemed extremely proud of the fact that he had worked for over twenty years as a police officer in the Mississippi towns of Yazoo City, Hollandale and Greenwood, serving as police chief in two of those locations. Jim is a big man, even larger than his father. According to a description of himself, he stands over six feet tall and weighs three hundred pounds. Based on his size alone, Jim Branch must have been a force to be reckoned with when he worked as a police officer.

Already, at age sixty-seven, Jim has experienced more than his share of personal loss. His voice broke as he told me how his sister Joyce died unexpectedly from complications after surgery, just a few weeks after she

began her first teaching assignment. He said he still feels the loss of his sister, and next to the day his father was shot, he considers the day his sister died the worst day of his life. Jim sadly recalled how his mother first told him that his daddy was shot and how he didn't believe her. His mother, he said, had delivered bad news about his father on at least two other occasions, one of them when Tillman was shot in the shoulder by a guy named Johnny Holmes and had suffered a wound that was neither serious nor life threatening. And Jim remembers another time when his daddy had an automobile accident that broke his jaw. But Tillman had cheated death on those occasions. So when his mother woke him on that fateful Easter Sunday morning in 1963, Jim thought the incident was just another one of those bad things that happened to Daddy, unfortunate events, but ones from which he had always survived. Only this time, Jim said, "Daddy didn't make it."

Jim vividly recalled the day his daddy was killed. He said that he was in bed asleep when his mother woke him to tell him that Tillman had been shot and killed. His voice became softer and lower as he spoke about that morning, and although it has been more than fifty years since Tillman's death, Jim still spoke through a veil of sadness as he related the story. Jim said that after his mother delivered the terrible news, he went with her to his daddy's club so that they could see for themselves if what they had heard really was true. He still didn't believe it, Jim said, but when he saw his daddy lying there in a pool of his own blood, reality suddenly sank in, and he knew at that moment that his life, at seventeen, and those of his family members had just changed forever.

Details are unclear about who made the call for help, but according to Hubert Simmons, a friend of my parents, his late wife, Mae Simmons, a telephone operator at the time, received the initial phone call. She quickly transferred the call to the local sheriff's office, and law enforcement was on its way when Tillman's family arrived at the club. When the sheriff and his men made it to the scene, they found Tillman lying in his own blood, and the man who had shot him was long gone. A copy of Tillman's death certificate shows he died at 2:30 a.m. on April 14, 1963, from "gunshot wounds inflicted in back," at a nightclub "while at work." The informant for personal information contained in the document was "Mrs. Tillman Branch" of Goodman. Holmes County coroner J.A. White signed the death certificate on April 22, 1963.

Tillman Branch's obituary, published in the *Star-Herald*, Kosciusko's newspaper, listed a wife and seven children among his survivors. According to the account of his death, Tillman was buried in Seneasha Cemetery in

The Juke Joint King of the Mississippi Hills

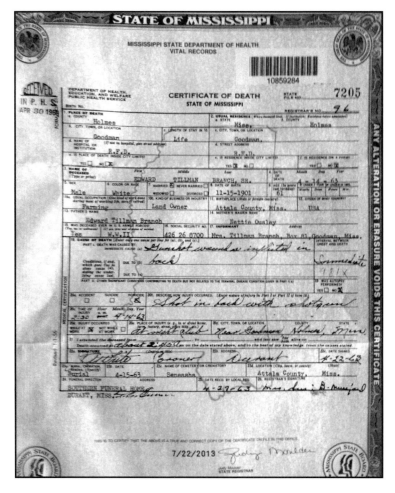

Tillman Branch's death certificate, signed by J.A. White, coroner. *Author's photo collection.*

Attala County. Other family members buried in the cemetery include Tillman's mother, Nettie Ousley Branch; his father, Edward Tillman Branch; a brother, Frederick Mabry "Doc" Branch; and his young brother, Henry Clay. Also the burial place for dozens of Tillman's extended family members, Seneasha Cemetery is located very near where Tillman was born and where he grew up.

12

THE ARREST AND CONVICTION OF MATTHEW WINTER

Details of what happened directly after Tillman was shot differ slightly according to who is telling the story. But at least one contact, who did not want his name mentioned in the book, told how the identity of Tillman's killer soon was determined by two of Tillman's sisters-in-law. He recalled how Maxine's sisters, one of whom was named Gladys, quickly sought out and provided the name of the individual to local law enforcement. Details about how Maxine's sisters determined the identity of the man who shot their brother-in-law are unclear. Allegedly, as a result of the two sisters' quick thinking and fast work, Matthew Winter, an eighteen-year-old black man from Kosciusko, was later arrested and jailed for the murder of the man that HoneyBoy Edwards had referred to in his autobiography as "the baddest white man in Mississippi."

An examination of available court documents revealed that Matthew Winter confessed in jail to David E. Crawley Jr., a Kosciusko attorney who had been hired by Winter's family to represent him. These same documents also discuss Winter's written confession to Holmes County law enforcement officials after he was arrested and while he was confined to the county jail in Lexington. According to the court documents, Winter's statement about what happened at Tillman's place agreed with other statements obtained during interviews conducted with Winter's relatives who either had witnessed the murder or who had heard details of the shooting directly from Winter. Neither law enforcement nor Winter's attorney interviewed any other witnesses to Tillman Branch's murder. An official in the Holmes County

Circuit Clerk Office in Lexington, the governmental entity that enforces and maintains criminal court records in Mississippi's counties, advised me that documents pertaining to Winter's actual arrest and subsequent confession no longer exist. This is true, as well, for the remaining case documents, including copies of the indictment, arraignment, plea agreement and sentencing. According to the county official authorized to respond to questions about Holmes County Circuit Court records, years of the county's criminal court documents were burned in a courthouse fire that occurred about two decades ago. That same official advised me that copies of documents relating to Winter's arrest, confession, indictment, arraignment and plea agreement also were lost in the fire.

The *Lexington Advertiser* published an article announcing Winter's indictment in the week's issue that followed his Sunday arrest. The heading reads "Murder Indictment in Branch Killing Expected Today." The text of the article follows:

> *Matthew Winters, a 20-year old [sic] Attala County Negro, will be indicted for murder by a Holmes County Grand Jury today in connection with the fatal shooting of Tillman Branch, Goodman white man, early Sunday morning. Branch, long time operator of the Blue Flame night club for Negroes, was killed almost "instantly" by a shot fired through a window at his place of business. Winters was arrested in Attala County later in the day Sunday and has been in the custody of Holmes County officers since Sunday afternoon. He has admitted the crime, according to reports. The Grand Jury, which has been in session earlier this month for the April term of court, was recalled this morning.*

As it turned out, Winter's later conviction, the result of a guilty plea, was appealed at the state level, where the decision was affirmed, and later it reached the Supreme Court of Mississippi. The highest court in the state soon handed down a decision in memorandum form that affirmed the lower court's ruling.

Based on copies of these court decisions, including a decision rendered by the U.S. Fifth Circuit Court of Appeals in New Orleans, I was able to reconstruct the official facts as they appeared in the court records in order to tell the story of what happened to Matthew Winter, the man who shot and killed Tillman Branch. Decisions rendered during the course of Winter's appeals cases reflect that Winter entered a guilty plea to avoid a trial. If he had pled not guilty, it is without a doubt that his case would

have been heard by an all-white male jury in Holmes County. Even more likely is the belief that Winter would have been found guilty and would have been sentenced to death in Mississippi's infamous electric chair. After all, Winter had already confessed to the murder, and eyewitnesses to the crime, allegedly all of them Winter's relatives, had provided statements that agreed with his confession.

Obviously, David E. Crawley Jr. believed he was doing his client a favor by advising Winter to enter a guilty plea, one that would most certainly please the district attorney, as well. There is no way to know what was going through Mr. Crawley's mind at the time, but he may have been concerned that defending a black man who obviously was guilty of killing a white man would not have been a good move for either his legal career or his social standing in the community. On October 21, 1963, Matthew Winter entered a guilty plea in Holmes County Circuit Court. As a result of the plea agreement, Winter was sentenced on October 24, 1963, to serve a life sentence in Parchman State Penitentiary in Sunflower County, near the Mississippi Delta town of Drew. Discussions between Winter's attorney and the Holmes County district attorney regarding the guilty plea likely spared Winter from "Old Sparky," as the state's electric chair was sometimes called. The true reality of the matter, however, was that eighteen-year-old Winter had been sentenced to spend his entire adult life behind prison bars.

13
WINTER'S APPEAL

A few years later, Winter had reason to believe his luck might change. Attorneys for the recently appointed federal Civil Rights Commission, with offices in the state capital city of Jackson, reviewed his case and subsequently filed an appeal styled *Winters v. State*, 244 So. 2d 1 (Miss. 1971) in the U.S. Court of Appeals, Fifth Circuit. The appeal requested that Winter's life sentence be vacated, and the grounds stated in the appeal were these:

> 1. *Petitioner was denied the equal protection of the laws in that at the time of petitioner's conviction upon his plea of guilty, negroes were systematically excluded from service on grand and petit juries in Holmes County, and, specifically, from the grand jury which indicted petitioner.*
> 2. *Petitioner was denied the effective assistance of counsel in that petitioner's "court-appointed" attorney failed to make proper investigation of the case, failed to confer with petitioner except for a brief period immediately prior to the entry of the plea of guilty, and failed to properly advise the petitioner.*
> 3. *Petitioner's plea of guilty was not understandingly and voluntarily entered.*

The circuit court, after an evidentiary hearing, denied the motion to vacate, finding the petitioner did have adequate assistance of counsel; that his plea of guilty was knowingly, intelligently and voluntarily entered; and that such a guilty plea waived all non-jurisdictional defects, including the alleged defect in the selection of the all-white Holmes County grand jury. Subsequently, the petitioner appealed the lower court's decision to the Supreme Court of Mississippi, where he was represented by the same

counsel who represented him at the state court post-conviction proceedings. This counsel was not the same counsel who represented Winter at the time of, and prior to, the entry of his guilty plea and at the subsequent sentencing hearing. Winter's grounds for appeal remained the same as those presented in post-conviction proceedings in the state court.

Civil Rights Commission Attorneys Appeal Case

Less than a year after Matthew Winter became an inmate in the Mississippi prison system, the Civil Rights Act of 1964 was signed by President Lyndon B. Johnson on July 2, 1964, and became law. Ten titles were included in that law, including Title V, which made the Civil Rights Commission a permanent body. In order to comply with Title V, Civil Rights Commission offices were established throughout the South, including an office in Jackson. Research has shown that dozens of the attorneys who sought out appointments or positions with the Civil Rights Commission did so because they believed strongly that all U.S. citizens should be fairly treated and that discrimination was illegal. More often than not, these young attorneys were individuals with true altruistic ideals that dictated personal and social service to others, even when their ideals might be in conflict with those dictated by society. Also bundled within these young attorneys' principles and ideals was a belief system that their voices could make a difference to those who had received unfair treatment in the often racially biased justice system of the South. And the attorneys assigned to Winter's case apparently accepted it with the notion that Winter deserved fair and equal treatment and possibly another day in court. In 1971, Roy S. Haber, George Peach Taylor—both of Jackson, Mississippi—and James Robertson of Washington, D.C., as attorneys for the petitioner-appellant, filed an appeal of the decision handed down by the Supreme Court of Mississippi to the Fifth U. S. Circuit Court of Appeals, located in New Orleans.

The Fifth Circuit Rules

On November 28, 1973, over ten years after the eighteen-year-old black man had arrived at Parchman State Penitentiary to begin a life sentence for murdering Tillman Branch, the U.S. Fifth Circuit Court of Appeals rendered

a decision in the matter of *Matthew Winter, Plaintiff-Appellant v. Thomas D. Cook, Defendant, Superintendent of Parchman State Penitentiary*, Case No. 71-3323. Winters was represented by attorneys Roy S. Haber, George Peach Taylor and James Robertson while A.F. Summer, Mississippi's attorney general, and Guy N. Rogers, assistant attorney general, represented the respondent-appellee. The court's panel included Chief Judge Brown, Senior Circuit Judge Rives and Circuit Judges Wisdom, Gewin, Bell, Thornberry, Coleman, Goldberg, Ainsworth, Godbold, Dyer, Simpson, Morgan, Clark, Ingraham and Roney. The Fifth Circuit's decision concluded that Winter's guilty plea was valid and that he had been furnished effective assistance of counsel when he plead guilty to the murder in 1963. The text of the appeals court's final decision dated November 28, 1973 is included in the book's appendix II.

At least one of the attorneys assigned to Winter's appeals case, Roy Haber, continues to practice law in the Pacific Northwest. Shortly before this book went into production, I spoke with Haber by telephone, and he briefly explained the Fifth Circuit's unfavorable decision in Winter's case. Although a period of forty years has lapsed since the appeal was decided, Haber still remembers the panel's decision was very close. Haber's lifelong career always has involved fighting for the legal rights of others, and in an online profile of the attorney, contained in *Profiles in the Law: Letters from Parchman Prison Farm*, author Janine Robben calls him a hero:

> In the story of the civil rights movement in the South, Roy Haber is a hero. But the Eugene [Oregon] lawyer didn't start out as the "fearless loner" described in "Worse Than Slavery," historian David Oshinsky's account of Parchman Farm, the notorious segregated prison, which Haber got integrated while working in Mississippi in the early 1970s.

Note: According to one of Tillman's sons, former governor J.P. Coleman phoned him about seven years after Winter began serving his life sentence at Parchman. Apparently, Winter was up for parole, and Coleman wanted to know what Tillman's son thought about Winter's possible release. Tillman's son told Coleman that he didn't think his father's killer should be released, and he said nothing happened. About three years later, his son recalls, he heard that Winter had been released from the state prison. It seems likely, based on conversations I have had with Branch family members and Winter's sister, that neither Tillman's family nor members of the Winter family were ever aware that Winter's conviction had been appealed all the way to the U.S. Fifth Circuit Court of Appeals.

14

THE RIGHT TO VOTE

In order to understand the justice system in place when Matthew Winter fatally shot Tillman Branch in Holmes County on April 14, 1963, and was sentenced to life in prison, it is important to understand the racial makeup of that county. According to John Ray Skates, in his book *Mississippi: A Bicentennial History*, Holmes County civil rights activities actually started in earnest in 1963 in Mileston. Located in the area where a large plantation named Marcella had existed in the 1800s, Mileston, according to Skates, was the home of over one hundred black farmers. Many of these farmers owned their own land. In his commemorative publication, Skates stated:

> *No other Mississippi county had as many independent black farmers as Holmes did—800 black farmers owned 50 percent of the county's land. None had as many owning rich Delta land as the 110 black Mileston farmers did. The Movement's first catalysts arose from these Mileston landowners.*

In 1963, voter registration efforts, including local protests and marches, were part of the landscape in Holmes County. On April 13, 1963, the day before Tillman Branch's murder, would-be black voters were turned away by white voter registration officials in Lexington, not many miles away from the site where Tillman was shot. Whether the previous day's activities had any impact on eighteen-year-old Matthew Winter is unknown to me at the time this book was written. Nor do I know the exact reason Winter made

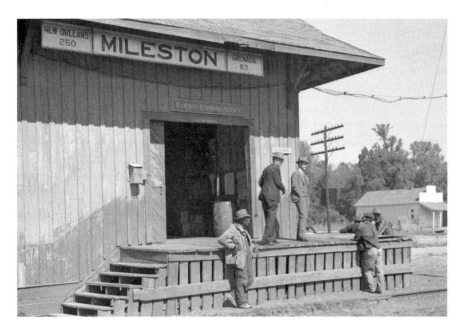

Mileston Railroad Station in Holmes County, Mississippi. *From FSA Photography Collection, Marion Post Wolcott, 1939. Library of Congress Digital Collection.*

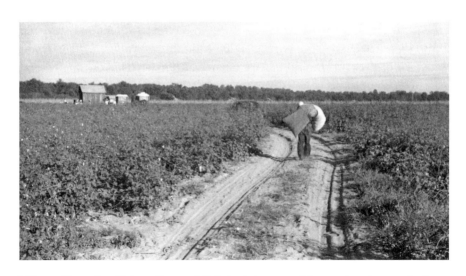

Mileston Plantation, Holmes County, Mississippi. A cotton picker carries a large sack of cotton across the field to the weighing house. *From FSA Photography Collection, Marion Post Wolcott, 1939. Library of Congress Digital Collection.*

The Raucous Reign of Tillman Branch

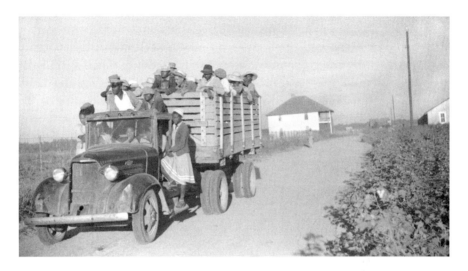

Mileston Plantation, Holmes County, Mississippi. Day Laborers are transported to cotton fields in a truck. *From FSA Photography Collection, Marion Post Wolcott, 1939. Library of Congress Digital Collection.*

a conscious decision that morning to shoot a fairly infamous and allegedly armed, tough-dealing white man.

No one has ever disputed Winter's guilt in the death of Tillman Branch, not Winter, his relatives who witnessed the incident or family members back home who first heard his story. But Winter and the attorneys who handled his appeals believed he was erroneously indicted by an all-white grand jury and that he had not been adequately informed by counsel that he could have appealed the illegality of the Holmes County Grand Jury's composition before he accepted a plea agreement. In an effort to be fair in telling this story, it is important to know that seating a grand jury of Winter's peers, in reality, would have been impossible in Holmes County in 1963, since most African Americans were unable to vote at the time Winter was indicted.

Prior to the passage of landmark legislation known as the Voting Rights Act in August 1965, those who wanted to register to vote were required to pay a poll tax that many people, black or white, were simply unable to afford. Many people in Mississippi's rural counties lived in poverty at the time, or they were little more than a state check or a paycheck away from it. But it was not simply a financial issue that prevented Mississippi residents and others throughout the South from registering to vote. State laws in place at the time required potential voters to read and understand portions of the U.S. Constitution arbitrarily selected by voting officials in charge of

registration. And in a county that included a large number of black residents who had little or no education and who may have been unable to either read or write, the latter requirement became an obstacle that was difficult, even impossible, for most to overcome. Further complicating the registration process were situations in which voter registration officials used some of the more difficult portions of the Constitution's text to test (and fail) those who attempted to register.

15

MATTHEW WINTER

When Matthew Winter was released on parole from Parchman State Penitentiary in 1974, he had spent the first ten years of his adult life behind bars. He was a free man, ready to begin a new life on the outside, far away from the prison life he had known. But as the saying goes, "It was not meant to be." Although the events and the timeline in which they occurred are not clear, Winter eventually made his way down to Hinds County, where he later committed two more homicides. According to the Mississippi Department of Corrections, Matthew Winter, inmate 61564, is currently serving concurrent life sentences for the two murders. At the time this book was written, Winter was housed at the Central Mississippi County Jail, a lower-level security lockup located southwest of Jackson, near Raymond, in Hinds County. Otherwise known as the "County Farm," the facility is one of many similar units scattered throughout the state. I have not investigated the details surrounding the two additional homicides, and therefore, information about the crimes are not included in this book. Almost a decade ago, Winter was reassigned to his current location from the Parchman facility in Drew, Mississippi. His daily duties at the County Farm primarily consist of manual labor on a work crew responsible for various types of maintenance activities. At sixty-eight years old, Winter has never been married, has no children and has spent the majority of his adult life behind bars in the Mississippi correctional system. In July 2013, I contacted the Mississippi Department of Corrections state office in Jackson and spoke with a communications officer there about arranging a visit with Matthew Winter. According to the

officer, Mississippi does not allow members of the media, including authors of books, to visit inmates in the state's correctional facilities. After I was advised of the state's prohibition regarding media visits, I drafted a letter to Winter and included writing paper and a self-addressed, stamped envelope for mailing his reply. That letter contained a set of questions asking specific details about what happened at the Blue Flame on Easter Sunday morning in 1963. Included with my letter was a list of questions asking Winter what he said to the young woman that day at Tillman's place, and what he and Tillman said to each other that would have caused him to leave, return with a shotgun and shoot Tillman in the back. Winter received the packet of questions and has since contacted me by phone. During that brief phone call, Winter agreed to answer the questions, saying "I have nothing to hide, and nothing to lose, because they can't do anything to me anymore. I will tell you anything you want to know." As it turned out, Matthew Winter was unable to answer the questionnaire without assistance. Shortly after our phone conversation, Winter contacted his youngest sister, Inez Winter, who lives in Kosciusko, and gave her my contact information.

Inez Winter Talks

Inez Winter subsequently called me, and I spoke at length with her. According to Inez, she was just thirteen years old when she learned her brother had shot and killed Tillman Branch. She first heard the news from her brother when he came home from Tillman's club after the shooting and told his family what happened. Inez is the youngest of fifteen children who once lived in Kosciusko. Since the Winter family was so large, and their house was very small, several children slept in each room. So Inez well remembers the events of early Easter morning 1963 when she was awakened by the voices of other family members talking to her brother Matthew. She recalls that it was after midnight when he got home and told his family how he had shot and killed Tillman Branch at Tillman's place in Holmes County. From that moment on, members of the Winter household were enveloped in fear, since they believed that local law enforcement soon would be barging in the door, ready to take young Matthew away to pay for what he did to the well-known white man. Not knowing what might happen to them, Winter's family "huddled together inside to wait it out." After all, it was the middle of the night, and they had no other place to go. Young Matthew could have run

away, but he waited inside, as well. The family's first thoughts may have been that they would be arrested, too. Over in Holmes County, about a decade before, another black family connected to Eddie Noel were locked in jail for almost a week because law enforcement believed they were withholding information about Noel's whereabouts.

THE BRIEFCASE

But things didn't happen exactly as the Winter family had feared. Two people did drive up to the Winter's house about 7:00 a.m., but it wasn't the sheriff or his men. Surprisingly, it wasn't law enforcement at all. It was Tillman's wife, Maxine, and her teenage son. But instead of a loaded gun, Maxine was carrying a large black briefcase. Once inside the Winter house, Matthew and his family received the surprise of their lives when Maxine opened the briefcase and revealed its contents: cold, hard cash, and lots of it. Maxine quickly explained how she wanted Winter to take the money, and she and her son offered to drive Winter to the airport in Jackson or Memphis and help him run away. According to Inez, who was listening from a corner of the room, Maxine offered to help her brother go anywhere he wanted, even to Europe. According to Inez, Winter told Maxine that he did not want the money nor did he want to run away. He knew that what he had done was wrong, and he planned to stay and take his punishment like a man. According to Inez, Maxine and her son, unhappy that Winter had refused their money and their offer to help him escape, reluctantly drove away. Inez recalled hearing her brother tell about what happened at the Blue Flame that made him mad enough to drive home to get a gun and go back over to Goodman to shoot Tillman Branch. He told his family that two black men at the club got into a fight, and because Matthew knew one of the men, he was trying to pull the two men apart and stop the fight. About the time he got involved, Matthew said Tillman came out from behind the counter and hit him in the face with his fist.

According to Inez, Winter told his family that Tillman must have believed he was the man who had started the fight. Winter did not hit Tillman back, but left the club instead. Winter told his family that he specifically left the club to drive home to get a gun. And he told them his plan was to use the gun to shoot Tillman when he returned to the club. Winter had plenty of time to tell his family the story as they waited for the law to arrive, since it was more

than twelve hours later, around 6:00 p.m. that Easter Sunday evening, when the sheriff showed up and arrested him.

Although Inez knows that her brother has made some bad choices, she still cares for him. She added, "He's an old man now; he's never been married, and he doesn't have any children that I know of. He has spent most of his life in jail…I think he has served enough time."

16
INEZ TALKS ABOUT TILLMAN

Inez was too young to go to Tillman's club, and she said that she would not have gone there anyway. But one of her older sisters and her sister's husband were present the night that her brother shot Tillman. That brother-in-law, Inez explained, is now deceased. Inez went on to say that she had known Tillman Branch since she was nine years old. Her parents, Lenora and Andrew Winter, and their children, including Matthew, had chopped and picked cotton on several pieces of land in Attala and Holmes Counties that Tillman Branch owned. According to Inez, Tillman sent a truck driven by one of his employees to Kosciusko to pick up African Americans who had hired themselves out to "work by the day" on his land. She remembered that workers were paid three dollars for every one hundred pounds of cotton picked. She added that when Matthew was a teenager, he could pick almost seven hundred pounds of cotton in a day, an accomplishment that earned him around twenty dollars for one day's work.

TILLMAN AND CLYTEE

As Inez told how a normal workday in one of Tillman's cotton fields involved backbreaking work in very hot weather, she recalled how she thought it very strange that Tillman's wife and son would be driving tractors out in the hot sun, while Tillman was sitting in his big black Cadillac under some shade

trees with a pretty brown woman named Clytee sitting close beside him. Inez said she never saw Tillman or Clytee work in the fields or drive the tractor. Inez described Clytee as a tall woman with long hair, about a twelve dress size, who was "always at Tillman's side." According to Inez, she saw Tillman and Clytee sitting in the car "all hugged up and everything," even when Tillman's wife and his son were nearby. Even as a child, Inez said, she knew the behavior she had observed was wrong, especially since she was old enough to know that Tillman was married to the woman who drove the tractor. Tillman's wife didn't seem to care, Inez continued, and she seemed oblivious to the behavior of her husband and the brown woman out in the Cadillac. Inez remembered that it was Clytee who passed out the cash to field workers at the end of the day. She also recalls how the truck driver sometimes stopped off at Tillman's store on the way home so that workers could buy food items like baloney, cinnamon rolls, snack cakes and soft drinks with the money they were paid that particular day.

Winter's sister described her brother as a good kid who liked dogs and liked to hunt. He started school at the grammar school in the Buffalo community near Kosciusko and later attended North Side and Tipton High Schools before he dropped out after the eighth grade. She said it was her brother's love of animals that got him a job at a local veterinarian's office. Inez recalled how her brother had often hunted with the veterinarian's sons when they were younger, and she believes their father hired Matthew to work at his veterinary office because he knew and liked Matthew and trusted him, as well. According to Inez, Winter had just bought his first car on the Saturday night before Easter Sunday in 1963, and he drove it over to Goodman to Tillman's club, where he planned to meet up with some friends and show off his new ride. Other members of the Winter family who went to the Blue Flame told Inez that the woman named Clytee worked behind the counter with Tillman and that she was the only person that Tillman allowed to handle the cash or to make change. According to Inez, Matthew, her sister and her brother-in-law remember that Clytee was working behind the counter at the club at the time of the shooting. Inez believes that Clytee may have told the sheriff or his men her own version of what happened to Tillman that morning. And she also believes that details provided by Clytee may explain the discrepancy between the account Matthew told his family and the information contained in the court documents, which stated that he tried to talk to a black female employee at the club.

Inez Winter and her family have always believed that Matthew was released from Parchman after ten years because he had behaved himself and

stayed out of trouble. She was unaware that his sentence had been appealed by attorneys who worked for the Civil Rights Commission. Inez has always known that her brother did, in fact, shoot Tillman Branch, and she said that he has never denied his guilt to her or to anyone else. And after all, her brother "did serve time for the crime he committed," so neither she nor members of her family thought it unusual that Matthew would have been released from prison after ten years. Inez acknowledged that killing someone is wrong. And she believes that because Matthew "shot Tillman Branch through a plate glass window in the back, it was even more wrong."

Winter's sister added that many folks in Kosciusko and around Attala County, blacks and whites alike, believe her brother "was a hero." She added that "it may be hard to get people to talk about it, but if you talk to some of the elderly folks, they will tell you the truth about how they felt about Matthew shooting Tillman. So many folks were afraid of that man." She further explained that after Tillman was killed, some of the local people talked about how glad they were that Matthew had shot Tillman, adding that if he hadn't done it, they might have done it themselves. After all, she said, "the man was having an affair with that woman right under his wife's nose. And that just wasn't right at all." According to Inez Winter, the "pretty brown woman" named Clytee left town very soon after Tillman was killed, and no one has seen her since. Inez added that some folks believe that Clytee left town so quickly because she feared for her own life.

As this book was being written, I made several attempts to determine if Clytee Parks is living or dead. I sincerely hoped that she was still living and would be willing to talk to me about Tillman Branch. Apparently, she knew him well and was privy to details about his life and his business activities that others who knew him may not have known. Unfortunately, all efforts to locate Ms. Parks were unsuccessful.

17
MATTHEW WINTER TELLS HIS STORY

On September 20, 2013, after receiving permission to visit Matthew Winter despite the previous prohibition, I interviewed him at the Mississippi Department of Corrections, County Farm Unit, near Raymond, Mississippi, where he works in landscape maintenance. A black man of slight build, with graying hair and a pleasant demeanor, Winter is currently serving two concurrent life sentences for a double murder he committed over thirty years ago. He is now sixty-eight years old and prides himself that he has had no disciplinary actions against him since 1966—a record, he says, in the Mississippi prison system.

Winter recalled that he pled guilty to the murder of Tillman Branch and began serving a life sentence at Parchman State Penitentiary in Drew, Mississippi, in late 1963. He still remembers how difficult it was for him to adjust to prison life in the beginning. Winter recalled how he was sent to "the Hole" for punishment about sixty times during the first few years before he realized that he had to learn to get along and follow orders in order to survive in prison. He said he served ten years of his life sentence for the murder of Tillman Branch, and he was released in 1973 after a lengthy appeal. In 1979, Winter was sentenced to Parchman again for the murder of a man and his son, and in 1997, he was transferred from Parchman to the Hinds County Farm near Raymond, Mississippi. At the County Farm, he is known by the name that prison officials and other inmates have bestowed upon him: "the Law." When I asked Winter how he had acquired the name, he explained that it was given to him out of respect for his efforts over the

years to talk younger inmates out of joining prison gangs, such as the Aryan Brotherhood, the Ku Klux Klan and other gangs with lesser-known names. Winter added that he also counsels new inmates about following prison rules and advises them about how to stay out of trouble. It sounds as if he serves in an unofficial conciliatory capacity in the prison community, and he is proud of his efforts to help other inmates effectively live in some type of harmony and deal with daily prison life.

Winter's Family

Winter is the fourth-youngest child of fifteen children born to the late Andrew Winter and his wife, Lenora Cross Winter. When he was young, Winter's very large family lived on a plantation near the Attala County community of Ethel, a plantation that was owned by a man named Jewy Belt. Matthew's father, Andrew, also known as "Bus," worked for Mr. Belt as a blacksmith. Winter told me that he attended school at the Buffalo School in rural Attala County, until his family moved to Rock Hill, a black community of about one hundred homes in Kosciusko. Most of the houses, he said, were owned by a well-to-do Kosciusko man named Mr. Sam Peeler, who rented the houses primarily to black families. In Kosciusko, Winter attended eighth grade at E.E. Peeler School, but he was expelled later that year for fighting with a young man named Edward Earl Peeler. According to Winter, Edward Earl Peeler, one of Oprah Winfrey's cousins, was a bully who frequently taunted Winter's sisters. When Winter got involved in the fight with Peeler, he was attempting to defend his sisters. Peeler also was expelled as a result of the fight, Winter said. Since there was no other school that Winter could attend, he went to work for Dr. J.C. Kuykendall, a local veterinarian. Winter's job duties consisted of testing and vaccinating cows around Goodman, Mississippi, and shoeing horses, something he had learned from his father, the blacksmith. Winter also went on farm calls with the veterinarian's wife and helped her deliver calves. When he wasn't busy with these tasks, Winter said he "bush-hogged" and cut trees around the veterinarian's place.

Winter Visits the Blue Flame

Winter first visited Tillman's club south of Goodman when he was about fourteen or fifteen years old. White people were not allowed inside the club, and there was no age limit to get in or to buy or consume liquor. Winter said that liquor sold in the club was either clear or brown moonshine that contained roughly 90 percent alcohol. He said that he usually went with two or three other guys, expecting to meet some girls. On the night that he shot Tillman Branch, Winter said that he drove to the club in his 1956 Ford Fairlane, a red-and-white two-door hardtop. Two girls—including one of his sisters and his girlfriend, whose surname was Veasley—and five "dudes," as they were referred to by Winter, rode in the car with him to the club. Winter added that Miss Veasley died a number of years ago. According to Winter, it was a usual Saturday night, and they planned to drink, dance and have some fun. Winter recalled that Elmore James and his band were playing there on the night of April 13, 1963. Winter described the Blue Flame as a fairly large, wooden building situated near a small lake on the left side of a rural road that ran west off Highway 51. According to Winter, club patrons entered through a front screen door that said "Welcome to Tillman Branch's." The inside of the club, according to Winter's recollection, was divided into four or five sections, with a bar, a pool table and a large dance floor across the back of the club. Each of the areas had its own manager. Two of these managers were John Henry Barnes, known as "Johnny," and Willie Barnes, black men who ran the club when Tillman Branch was not there. A woman named Clytee, who had chocolate colored skin, was another manager who "had power over the women and some of the men."

The Dance

Shortly after Winter and his friends arrived at the club and Winter had danced a few dances with his girlfriend, Tillman Branch approached Winter and told him to tell his girlfriend to dance with him. Winter said that he told Branch "if she wants to dance with you, she can dance. If she don't, she don't have to." Tillman replied, "You know you are talking to Mr. Tillman Branch, and you can't talk to me that way." Matthew responded, "I ain't telling her nothing." According to Winter, the next thing he knew, Branch came up behind him on his right side and hit him in the right jaw with a pistol. Winter quickly realized that some of his "teeth felt loose" and

that he had "a lot of blood in his mouth." Later, he would be told that his jaw had been fractured.

As suddenly as Branch had hit Winter in the jaw, four or five of Branch's employees appeared with their pistols drawn, ordered him to leave the club and directed him out to his car. As he approached the car, Winter found that his friends were already inside, where they had sought cover when the altercation in the club began. I asked Winter why his friends had run out on him when they must have known that he needed help, and he told me they were afraid of Tillman Branch and his men. They believed their own lives would have been in danger if they had come to his aid. After Winter was forced into his car by Branch's men, he drove home to Kosciusko. During the almost twenty mile drive home, Matthew told his friends that he planned to go home, get a gun and return to the Blue Flame to shoot Tillman Branch. Several of his friends told him they would drive back with him, but Winter insisted that he wanted to drive back alone and take care of the matter on his own. According to Winter, his friends, his sister Ethel and his brother-in-law Allen Ford, who had decided to leave when the incident occurred, were also in the car. As he drove home to Kosciusko, his friends and relatives in the car continued to try to talk him out of returning to the club. Winter subsequently dropped off those individuals who had ridden home with him at two places in Kosciusko, including the Rock Hill community where he lived, and he proceeded to go in his house to get the shotgun.

Winter Returns to Goodman

Acting against the advice of those who cared about him most, Winter left with a shotgun and drove back to Goodman alone. When he reached the vicinity of the club, Winter parked his car down the road and out of sight. From that point, he proceeded on foot in the dark through the trees and undergrowth. As he neared the building, Winter said that he saw Tillman Branch, Johnny Barnes, Willie Barnes and three more men standing out front. He continued on foot under the cover of darkness, protected by the dense vegetation until he was around thirty to forty yards away. At that point, Winter said, he was looking directly at Branch, who was facing him, and he fired the shotgun containing double-ought buckshot, hitting Branch in the upper abdomen. The other men began firing, but since they could not see Winter standing behind trees in the dark, they fired in the opposite direction.

Former residence of Tillman Branch and his family. The family lived here in the 1950s and early 1960s. *Author's photo collection.*

The lake near Tillman Branch's former juke joint south of Goodman, Mississippi. *Author's photo collection.*

Former site of Tillman Branch's juke joint where he was shot and killed on April 14, 1963. *Author's photo collection.*

WINTER WAITS FOR THE SHERIFF

Winter remembers that he quickly left the scene and drove home where his family was waiting. I asked him if he told his parents and siblings what had happened, and he said that he did, adding that his sister and his brother-in-law had already told the rest of the family about the incident they had witnessed inside the club. And on Easter Sunday morning, April 14, 1963, eighteen-year-old Matthew Winter began a wait that he knew would certainly end with his arrest. Winter told me that he had no intention of hiding or running away. He knew what he had done was wrong, but he believed that what Tillman Branch had done to him was wrong, too. Winter said he was ready to tell his story and to face the consequences of his actions, but he chose not to turn himself in. As it turned out, Winter had most of the day that Easter Sunday to reflect on what had happened. It was late that afternoon when Sheriff Andrew Smith, Deputy T.J. Floyd and three or four other sheriff's deputies finally arrived at the Winter household to arrest young Matthew for the murder of bootlegger and juke joint owner Tillman Branch. Winter recalls that he was not mistreated when he was arrested and jailed, either in the Attala County jail or in the Holmes County jail, where he was soon transferred. In fact, Winter remembers that Sheriff Smith told

Old Holmes County jail, where Matthew Winter was incarcerated after his arrest for shooting and killing Tillman Branch. *Author's photo collection.*

him that he was sorry he had to arrest him for shooting Tillman Branch. Winter added that some local people believed he had done something they had often considered doing themselves but were afraid to actually do it.

I asked Winter if any of Tillman's family visited him or talked to him at any time after the shooting. Winter told me that Tillman's wife, Maxine, visited him soon after he was jailed in the Holmes County jail in Lexington. I questioned him about the purpose of Maxine's visit, and Winter told me that Maxine really wanted to ask him questions about Tillman's possible involvement with a woman at the club. Winter told her he didn't "want to talk about stuff like that," and Maxine left. He says she never visited him again. I also asked Winter if he is sorry that he shot and killed Tillman Branch. As most of us know, remorse can come in many forms, and Winter expressed his sentiments in a few well-chosen words. He told me that he is sorry that "things happened like they did," and he blamed his actions that Sunday morning in 1963 on age, immaturity and bad judgment.

Note: Winter's account of the shooting as he related it to me differs greatly from the coroner's report that states Tillman was shot in the back, and it conflicts, as well, with available court documents. Is Winter's account the real deal? It may be just that. I have always wondered how Matthew Winter, or anyone for that matter, could have shot Tillman Branch in the back through a plate glass window and remained alive to tell about it. If Winter had actually shot Tillman in the back as the coroner's report shows and the court documents detail, it is almost certain that Winter would never have left the area alive. Tillman's men would have shot him on the spot. Although Tillman was not afraid of anybody or anything, he would never have made himself vulnerable to anyone outside the club by standing with his back to a plate glass window, especially after he and his men had forced an angry patron to leave, and particularly if he thought it possible that patron might return with a gun. I have been to the site, and the club's former location was in a remote location, near dense woods with plenty of places to hide. The narrow gravel road is about three-fourths of a mile in length and little more than one car wide. It is entirely possible that Winter could have parked his car, as he said, hiked through the woods to the club, hidden behind the spring foliage and shot Tillman with his shotgun in much the same way he would have shot a deer.

AFTERWORD

Tillman Branch, the bootlegger and nightclub owner, was a man who had money and social standing in the community. And the fear he engendered in many of those who knew him, both black and white, was his power. His world and the world of Matthew Winter, the poor, young black man who killed him, were diametrically opposed long before that fateful morning on Easter morning 1963. What happened that day was a tragic and unforgettable event in the lives of the families of both men. But it may have been an incident that created a much-needed dialogue about long-existing social and economic problems in that part of the world. Amazingly, all but two of Tillman's children, an infant son and a daughter who died when she was a young adult, have lived long and productive lives. During the course of writing this book, I found that Tillman's immediate and extended families are still quite loyal to the man they called Daddy or Uncle Tillman. These individuals remember him as a loving father, uncle, cousin or nephew, not for what he did for a living or for the manner in which he conducted his nonfamily life. Although Tillman's killer, Matthew Winter, has been convicted of murder twice more since Tillman's death, his family continues to love and support him, as well. And in the racially biased and socially conservative society into which each man was born and in which each lived, these outcomes seem like small miracles.

APPENDIX I
NOTES

MISSISSIPPI ARTISTS, WRITERS, MUSICIANS AND POLITICIANS

The State of Mississippi has a reputation for having produced a long list of artists, writers and musicians, along with a few popular and not-so-popular politicians. Eudora Welty and William Faulkner are best known among the state's writers, and Elvis Presley, Mahala Jackson, Faith Hill and B.B. King are at the top of the list of well-known musicians. One of my former classmates, Gary Walters, is known throughout the world for his colorful Mississippi Delta scenes, and Jacob, one of his three sons, has made a name for himself as a remarkable contemporary artist. Among the state's more current politicians are former governor Haley Barbour and Trent Lott, a former U.S. senator. But some of Mississippi's best-known musicians, perhaps, were the early bluesmen who began their careers in the cotton fields and juke joints of the Delta and Hills. Several of these blues musicians were once residents of Holmes County. According to most accounts, Elmore James, a man who was revered for his slide guitar ability, got his start in some of the dozens of nightclubs that dotted the Holmes County countryside. James became a local hero, and when he died, he was buried in the small Holmes County cemetery at New Port Church.

Appendix I

Although his hometown was Itta Bena, Mississippi, world-famous blues guitarist and singer B.B. King is said to have once lived in Lexington. Many of those who knew Elmore James and B.B. King have said the two men often played at a Holmes County nightclub just south of Goodman, Mississippi, a place that was owned and operated by an Attala County man named Tillman Branch. And it was in these dark, smoky and often rowdy places that a style of music called the blues evolved into the present day art form known as the Mississippi Delta Blues. One mystery remains, however. No one knows for sure whether the juke joints began as music venues for singing and dancing or as places to drink a little moonshine and have a little fun. But most folks who have heard the stories, and certainly those who have been to the clubs, would probably say that moonshine probably started it all.

Another well-known Holmes County native son was Edmond Favor Noel, who was elected governor of Mississippi in 1907. Born on his family's plantation in 1836, the son of Leland Noel, former governor Noel served in the Mississippi State Senate before he became the state's thirty-seventh governor, a position he held from 1908 until 1912. According to online information available at Mississippi History Now, Noel's term as governor is described in the following manner:

> *His administration was characterized by many progressive reforms, especially in education. Among the major educational reforms passed during his term were the consolidation of rural school districts, the establishment of agricultural high schools which later became the state's junior college system, the establishment of a teachers college at Hattiesburg, and the beginning of agricultural extension work.*

In addition to being remembered for the educational reforms made during his term in office, Noel and his wife, Alice Tye Neilson, have been credited with preventing the demolition of the Mississippi Governor's Mansion and that of the Old Capitol Building in Jackson, Mississippi. The mansion was renovated instead of being torn down, and during the renovation process, the couple lived for a time at the King Edward Hotel, just across Capitol Street from the governor's official residence. Eventually, the Old Capitol Building, which had already been replaced with the New Capitol Building in 1903, was turned into a museum that still exists today. Although the Old Capitol Building suffered rather extensive roof and water damage during Hurricane Katrina, repairs have been made, and the beautiful old building is still a focal point when traveling east on Capitol Street in downtown Jackson. Several

other memorable actions took place during Noel's years as Mississippi's governor. Among these actions was the passage of "a child labor law, a pure food law, the establishment of a state charity hospital, and the enactment of a statewide prohibition law, which outlawed the production and sale of alcohol." Over a century later, it seems ironic that a state prohibition law passed during Noel's administration was likely the impetus for the many whiskey stills and nightclubs where moonshine was sold that sprang up throughout rural Holmes County, where Noel was born.

Branch Family Genealogy

The Branch family in Virginia has been traced to Christopher Branch of England, and his wife, Mary Addie. According to a book entitled *Branchiana*, written by James Branch Cabell, Christopher and Mary, along with their young son, Thomas, set sail from England in 1620 and headed for America on a ship named the *London Merchant*. After they arrived in Virginia, near the location of present-day Charles City, the couple settled on land that became the site Branch named Kingsland Plantation. By 1639, Kingsland had grown to 450 acres, on which Christopher Branch raised tobacco. Other plantations grew up along the James River, and foundations of some of these original plantation houses can still be seen today by visitors who take the James River Plantation tour. As the years went by, the Branch family grew and prospered, and its descendants married into other old Virginia families. While marriages bound the families together through blood, they also connected families through land ownership and often increased their social standings. Christopher Branch's daughters and granddaughters all married well, including one of his granddaughters, a young woman named Mary, who would later become great-grandmother to President Thomas Jefferson.

Born in Brunswick County, Virginia, in 1798, Edward Tillman Branch was the son of Edward Branch and Martha Tillman Branch. According to early records, Edward, the father, had lost two previous wives before he married Martha Tillman in Amelia County, Virginia, in February 1797. Their marriage ceremony was performed by Edward Dromgoole, a minister in the Methodist Episcopal Church who later assisted in the formation of Methodism in the Mississippi Territory. Based on laws of primogeniture in place at the time of his father's death, the eldest son in the family inherited his father's property. Edward Tillman Branch, as his father's youngest son,

Appendix I

received only four hundred acres of land from his father's estate. Within a short period of time, Edward sold the land and migrated from his native Virginia to Mississippi, where new lands obtained through treaties with the Choctaw had been opened up to settlement. It seems likely that Edward traveled with other Branch family members as they migrated from Virginia into North Carolina, through Tennessee and into northern Mississippi, since several Branch families were already living in Panola and Madison Counties before 1850.

The first mention of Edward Tillman Branch in Mississippi records was in the marriage index records at the Hinds County Courthouse in Raymond, Mississippi. According to the index (the actual records were destroyed during the Civil War), Edward T. Branch married Winiford Ragland on March 24, 1830. Winiford—or "Winney," as she was known—was the daughter of John Ragland and his wife, Elizabeth Smith Ragland, who had migrated to Mississippi from Newberry, South Carolina. When the couple married, Edward was thirty-two, and his young bride was only sixteen. According to *The History of Leake County, Mississippi: Its People and Places*, a book compiled by Mac and Louise Spence, the first group of residents to serve as county officers was elected on April 10, 1834. Edward Branch was one of the first men elected to serve on the Leake County Police Board, an entity that later became the County Board of Supervisors. Branch's presence in Leake County in 1834 establishes that he and Winney Branch must have moved into Attala County sometime between his election in 1834 and 1850, when they were enumerated as residents of Beat 4, Attala County, on the U.S. census of 1850. Attala County land transactions recorded during that same time period indicate Arthur Ragland, most likely Winney's brother who died in 1847, transferred ownership of some Attala County land to one Edward T. Branch. Edward and Winney Branch's household in Attala County in 1850 included three children, one of whom was Joseph Arthur "Joe" Branch, who would become my paternal great-great-grandfather, Clark Commander Branch's grandfather. Joe's brother, Edward Tillman "E.T." Branch would be born in November of that same year. And over one hundred years later, E.T.'s son, Edward Tillman Branch, a man known simply as Tillman, would become the subject of this book.

APPENDIX II
COURT TRANSCRIPTIONS

489 F.2d 174
Matthew WINTERS, Petitioner-Appellant,
v.
Thomas D. COOK, Superintendent of The Mississippi State Penitentiary, Respondent-Appellee.
no. 71-3323.
United States Court of Appeals, Fifth Circuit.
Nov. 28, 1973.
Roy S. Haber, George Beach Taylor, Jackson, Miss., James Robertson, Washington, D.C., for petitioner-appellant.
A.F. Summer, Atty. Gen., Guy N. Rogers, Asst. Atty. Gen., Jackson, Miss., for respondent-appellee.
Before BROWN, Chief Judge, RIVES, Senior Circuit Judge, and WISDOM, GEWIN, BELL, THORNBERRY, COLEMAN, GOLDBERG, AINSWORTH, GODBOLD, DYER, SIMPSON, MORGAN, CLARK, INGRAHAM and RONEY, Circuit Judges.
CLARK, Circuit Judge:

1

The factual circumstances of Winters' crime and the procedural context in which his subsequent guilty plea was entered are set out in detail in the district court's opinion, published at 333 F. Supp. 1033, and need not be reiterated at length here. Winters was indicted by the Grand Jury of Holmes County, Mississippi, on a charge of murder arising out

Appendix II

of the shooting death of one E.T. Branch. On the advice of retained counsel Winters pled guilty to that charge and was sentenced to life imprisonment. Winters now seeks federal habeas relief alleging that Negroes were illegally excluded from the grand jury which indicted him, that his guilty plea was not voluntary and intelligent, and that he was denied effective counsel.

The Grand Jury Discrimination Claim

2

Based upon two separate but factually interrelated legal theories we hold that Winters may not assert the alleged grand jury discrimination as a grounds for habeas relief. First, his counsel's actions constituted a valid waiver to all objections to the composition of the grand jury, and second, Winters' guilty plea foreclosed his assertion of that constitutional claim.

3

Waiver by Counsel—As the court below found on clear record evidence, Winters' attorney fully considered the possibility of raising constitutional objections to the racial composition of the grand jury, but rejected that course of action in favor of a plea of guilty. By such a plea his client was assured of receiving the prosecution's recommendation of a life sentence (with the possibility of a parole after serving ten years), thus avoiding what counsel reasonably considered was the distinct possibility of the death sentence. Counsel testified that the threat of his urging these constitutional objections to the jury selection procedures was the 'pry pole' that he used in getting the state to allow the defendant to enter a guilty plea. In his opinion as an experienced criminal attorney this procedure utilized the unlawful condition in the most effective way. Even the most skillful trial tactician should be hard pressed to fault counsel's considered and conscientious strategy to waive this option in return for practical assurance that his client would not be executed. Where, as here, a competent attorney who is well-versed in the defense of murder charges deliberately refrains from making a known constitutional objection to the composition of a grand or petit jury for strategic purposes, there has been a deliberate by-pass and waiver under *Fay v. Noia*, 372 U.S. 391, 83 S.Ct 822, 9 L.Ed.2d 837 (1963).

Appendix II

4

The effect of this waiver was not vitiated by the attorney's failure to consult with Winters about the constitutional objections to the jury composition. As *Fay* points out, '(a) choice made by counsel not participated in by the petitioner does not automatically bar relief.' 372 U.S. at 439, 83 S.Ct. at 849. The implication of this last statement—that some strategic decisions which entail the waiver of a constitutional right may be made by counsel without consultation with the accused—was made express in *Henry v. Mississippi*, 379 U.S. 443, 85 S.Ct. 564, 13 L.Ed.2d 408 (1965).

5

Although trial strategy adopted by counsel without prior consultation with an accused will not, where the circumstances are exceptional, preclude the accused from asserting constitutional claims, see *Whitus v. Balkcom*, 333 F.2d 496 (5th Cir. 1964), we think that the deliberate bypassing by counsel of the contemporaneous-objection rule as a part of trial strategy would have that effect in this case.

6

379 U.S. at 451-452, 85 S.Ct. at 569. *Henry* requires inferior federal courts to determine whether the circumstances of a particular case are in the exceptional category from which the bar of waiver, created by the good faith actions of a criminal defendant's attorney, has been lifted.

7

The majority opinion of the panel that originally decided this cases, which we today reverse, would have created a per se rule that even an intentional, strategic waiver by a lawyer of his client's constitutional rights cannot be binding. Specifically, the opinion stated:

8

Both the State courts and the district court in this case held that Winters' plea of guilty waived his right to complain of the array of jurors in Holmes County. The rationale for such view is that Winters' lawyer knew of the right and that by failing to raise the objection counsel effectively waived the right for Winters. But it is axiomatic that Winters is the one who must make the waiver, not his attorney. Winters had no idea that he could object to the jury composition. Before a waiver can be effective it must be knowingly given. Since Winters had not been informed of the right, his waiver did not encompass its relinquishment.

9

466 F.2d at 1395-1396. Under this reasoning, the exception which *Henry* explicated would have swallowed the basic rule on which it is engrafted.

Appendix II

'Axiomatic' or not, this syllogism—that since the rights are those of the defendant, he alone may waive them—must be rejected. To require an explanation of only the most important rights which arise during the course of a trial, with the advantages and disadvantages of raising each issue, in terms that would enable a defendant to make an intelligent and knowing waiver creates a heavy enough burden for both clients and lawyers. We refuse to enlarge the attorney's duty to include the responsibility to inform the defendant of every possible constitutional claim. See Developments in the Law—Federal Habeas Corpus, 83 Harv.L.Rev. 1038, 1110-11 (1970).

10

Our concern here is more basic than the effect of such a rule on already crowded court dockets; it is that the rule contended for by Winters would make it virtually impossible to conduct a criminal trial in the future. Looking past the disruptive effect on counsel and the confusing impact on the defendant himself, it would be a futile command to require that a trial judge continually satisfy himself that the defendant was fully informed as to, and in complete accord with, his attorney's every action or inaction that involved any possible constitutional right.

11

Our Constitution has been held to afford all criminal defendants the right to counsel. The cardinal precept upon which the establishment of this right is predicated is that most defendants are untutored in the law and are unqualified to conduct their own defense. It would be incongruous to reflexively allow a defendant such as Winters to void his conviction when his privately-employed lawyer did what he was retained to do—use his skill and knowledge of the law to further the best interests of his client—because the lawyer did not first reason out his every action with his client and obtain his knowing agreement.

12

Though there are instances where a defendant's personal waiver is required, our examination of the facts of this case in search of the exceptional circumstances required by *Henry* discloses no such personal waiver right was present here. Case law demonstrates that the exceptional circumstances which justify a requirement that the defendant personally waive the right vouched-safe may be grouped in two broad categories: first, where there is evidence of fraud, or gross negligence or incompetence on the part of the defendant's attorney; and, second, where an inherently personal right of fundamental importance is involved.

Appendix II

13

As to the first category, there is absolutely no evidence in this record that the attorney for the defendant did anything other than to conscientiously represent the defendant to the best of his ability. As discussed infra, there is no substance to any charge of incompetence or negligence in this case. Thus, we need discuss here only Winters' attack on the good faith of his selected attorney, based on his interpretation of the language in United States ex rel. *Goldsby v. Harpole*, 263 F.2d 71, 82 (5th Cir.), cert. denied, 361 U.S. 850, 80 S.Ct. 109, 4 L.Ed.2d 89 (1959), where this court stated:

14

As Judges of a Circuit comprising six states of the Deep South, we think that it is our duty to take judicial notice that lawyers residing in many southern jurisdictions rarely, almost to the point of never, raise the issue of systematic exclusion of Negroes from juries.

15

This language from *Goldsby* has in subsequent cases been construed to support the proposition that this court must take judicial notice that white lawyers in this circuit almost always will sacrifice their Negro clients' rights to be tried by a constitutionally selected jury out of a fear of community opprobrium or social ostracism. Whether such judicial notice was court recognition of adjudicative facts or of legislative facts, see K. Davis, Administrative Law Treatise 15.03 (1958), the majority of the court en banc now announces that it does not consider such breach of trust by counsel to be so prevalent in any jurisdiction of this circuit that this court should, in the absence of proof, place all or even some lawyers in this circuit under the cloud of such an accusation. Winters, and those raising a similar defense in the future, may not rely on any court to 'notice' without proof that attorneys in this circuit are not to be trusted to make a strategic or tactical decision to challenge unconstitutional jury discrimination. When the record discloses that an attorney has deliberately waived a right his client may have had to raise an objection to the racial composition of a grand or petit jury, this court will not, in the absence of proof, assume that the attorney breached any obligation to his client.

16

Goldsby excused a timely failure to object to an illegally constituted petit jury based upon a recognition that the lawyer had been presented with a Hobson's choice between accepting an improper jury and raising a challenge only to secure to his client the right to be tried by a properly chosen venire which was prejudiced by the attack on 'the system.' This reasoning, which

Appendix II

is valid whenever such probable prejudice could be demonstrated to exist, is inapplicable to the facts here. *Goldsby* itself recognizes that while the Hobson's choice will excuse an attorney's failure to timely object to an illegally constituted petit jury it will not excuse a failure to object to the racial composition of a grand jury. 263 F.2d at 80-81, 84. See *Whitus v. Balkcom*, 333 F.2d 496, 501-502 (5th Cir.), cert. denied, 379 U.S. 931, 85 S.Ct. 329, 13 L.Ed.2d 343 (1964). See also *Tollett v. Henderson*, 411 U.S. 258, 93 S.Ct. 1602, 36 L.Ed.2d 235 (1973). In the case at bar we need not reach the petit jury issue either. Winters' counsel never faced this choice. His decision to use the potential of raising such an objection to assure his client safe passage past the hazard of a death sentence obviated any need to make the 'grisly choice' as to the jury he did not face. Therefore, we need not decide whether the 'Hobson's' problem had dissipated at the time of Winters' plea or whether it persisted until such time when Negroes were regularly called for jury duty in the county.

17

Since it is clear that there is no evidence here of breach of trust, fraud, or overreaching, and since we hold that Winters' counsel was neither negligent nor incompetent, this case does not fall within the first branch of exceptions to the general rule that personal waiver is not required.

18

It does not fall within the second branch of exceptions either. It is not such an inherently personal fundamental right that it can be waived only by the defendant and not by his attorney. Such personal fundamental rights include the right to plead guilty (which of course encompasses the waiver of numerous rights), the right to waive trial by jury, the right to waive appellate review and the right to testify personally. See Developments in the Law—Federal Habeas Corpus, 83 Harv.L.Rev. 1038, 1011 n. 102 (1970). Without intimating any opinion as to whether these fundamental rights may ever be waived by an attorney for his client, it is sufficient for the purposes of this case to point out that the right to be indicted or tried by a constitutionally composed jury is not one of the rights traditionally considered so inherently personal that only the defendant may waive it. In United States ex rel. *Goldsby v. Harpole*, supra, this court stated:

19

The evidence in this case...fairly considered shows no waiver by the appellant himself but at most by his counsel without his express authority. In ordinary procedural matters, the defendant in a criminal case is bound by the acts or nonaction of his counsel. That might extend to the waiver

Appendix II

of the objection that Negroes were systematically excluded from the grand jury. In noncapital cases, it might extend to a like waiver as to the petit jury. It might extend to such a waiver even in capital cases, where the record affirmatively shows that the particular jury was desired by defendant's counsel after conscientious consideration of that course of action which would be best for the client's cause.

20

263 F.2d at 83.

21

In *Whitus v. Balkcom*, supra, noted with approval in *Henry v. Mississippi*, supra, 379 U.S. at 451-452, 85 S.Ct. at 569, we quoted the language of *Goldsby* and stated that in the circumstances described there could be a 'true waiver based on a free option.' 333 F.2d at 502.

22

In *Cobb v. Balkcom*, 339 F.2d 95 (5th Cir. 1964), there was no evidence of any deliberate bypass by counsel for the defendant. The court properly held that the lawyer's statement that he was satisfied with the jury was insufficient to show an intent to waive a right to achieve a strategic advantage. The court specifically pointed out that we are not presented here with a waiver case where a particular jury was desired by defendant's counsel after conscientious consideration of that course of action which would be best for his client's cause, see United States ex rel. *Goldsby v. Harpole*, supra. 339 F.2d at 101 n. 2.

23

Finally, United States ex rel. *Seals v. Wiman*, 304 F.2d 53 (5th Cir. 1962) involved a situation where the evidence on which to base the constitutional claim was unknown to the defendant or his counsel at the original trial, and was not easily ascertainable. Since the evidence was not available it was held that there could be no deliberate bypass. See 304 F.2d at 69. See also *Whitus v. Balkcom*, supra, 333 F.2d at 502.

24

This court thus does no more than adhere to its established rule that a constitutional objection to the composition of a grand or petit jury may be waived by an attorney without consultation with his client where there is 'conscientious consideration of that course of action which would be best for his client's cause.'

25

Waiver by Guilty Plea—In addition to the attorney's valid waiver of the jury discrimination claim, there is an alternative basis for our holding that such a claim could not provide a basis for habeas relief in this case. Since the

original panel decision in this cause the Supreme Court has made it manifestly clear that Winters' guilty plea is a complete bar to habeas relief grounded on grand jury discrimination. *Tollett v. Henderson*, supra. There the court, relying on *McMann v. Richardson*, 397 U.S. 759, 90 S.Ct. 1441, 25 L.Ed.2d 763 (1970); *Parker v. North Carolina*, 397 U.S. 790, 90 S.Ct. 1458, 25 L.Ed.2d 785 (1970); and *Brady v. United States*, 397 U.S. 742, 90 S.Ct. 1463, 25 L.Ed.2d 747 (1970), stated that 'respondent's guilty plea here...forecloses independent inquiry into the claim of discrimination in the selection of the grand jury.' 411 U.S. at 266, 93 S.Ct. at 1607. *Tollett* requires this court to reject Winters' petition for relief based on his jury discrimination claim if we find that his guilty plea was voluntary and intelligent and that he was afforded effective counsel. We turn next to those issues.

THE VALIDITY OF THE GUILTY PLEA

26
Knowledge of Every Possible Constitutional Right is Not Required— Petitioner grounds his attack on the voluntary and understanding character of his guilty plea by arguing that he was never advised that he had a right to object to the systematic exclusion of Negroes from the grand jury that indicted him and from the petit jury which would have tried him had he gone to trial. This in itself, however, is not enough to render his plea invalid. As the Supreme Court stated in *Tollett v. Henderson*, supra:

27
A guilty plea, voluntarily and intelligently entered, may not be vacated because the defendant was not advised of every conceivable constitutional plea in abatement he might have to the charge, no matter how peripheral such a plea might be to the normal focus of counsel's inquiry...

28
The principal value of counsel to the accused in a criminal prosecution often lies not in counsel's ability to recite a list of possible defenses in the abstract, nor in his ability, if time permitted, to amass a large quantum of factual data and inform the defendant of it. Counsel's concern is the faithful representation of the interest of his client and such representation frequently involves highly practical considerations as well as specialized knowledge of the law. 411 U.S. at 267, 93 S.Ct. at 1608.

Appendix II

29

Just as *McMann v. Richardson*, supra, stands for the proposition that habeas corpus relief is not ipso facto available where counsel has given erroneous advice to his client who pleads guilty as a result thereof, similarly a federal habeas court will not intervene where the attorney merely failed to inform his client of a single possible constitutional claim which he thought best to use as a coin for barter with the prosecution. Where the attorney reached a more than arguably correct decision involving many complicated and uncertain variables, we will not impose a rule requiring that he inform his client as to the precise nature of each variable. A lawyer does not have to conduct a course in constitutional law for his client to validly discharge his position of trust.

30

Winters may not attack the voluntary and intelligent character of his guilty plea by pointing to his counsel's failure to discuss either his existing right to challenge the racial composition of the grand jury or his potential right to challenge any unconstitutionally constituted petit jury in the event he determined to go to trial. The character of the plea may be challenged only by petitioners showing that his counsel's advice was not 'within the range of competence demanded of attorneys in criminal cases.' *McMann v. Richardson*, supra; *Tollett v. Henderson*, supra.

31

The Effectiveness of Winters' Counsel—We have no doubt that the advice Winters received from his counsel met the standards of *McMann*. Winters predicates his ineffective counsel claim both on the failure of his retained counsel to advise him of his constitutional right to challenge the jury composition and on a more general claim that the attorney did not devote the necessary time, energy, and interest to petitioner's defense.

32

The merits of the more specific charge—the failure to inform Winters of his right to challenge the grand jury—have been amply dealt with in the earlier portion of the opinion. Suffice it to say that, just as an attorney's failure to consult with his client does not necessarily vitiate the attorney's waiver of a constitutionally protected right, an attorney's failure to consult with his client on every possible constitutional claim does not constitute ineffective counsel.

33

Winters' more general claim of ineffective counsel is settled by the district court's conclusion that the claim was not founded in fact.

34

[The attorney] interviewed petitioner at the Holmes County Jail promptly upon being employed and prior to the arraignment. This could not have

Appendix II

been more than five days after the employment, and was probably less. After interviewing petitioner, the attorney promptly undertook such investigation as in his judgment was required. He then sought a mental examination of petitioner in order to determine whether or not the defense of insanity would be available. He conferred not only with petitioner, but with members of his family and with the state's attorneys on numerous occasions. He was fully aware of all of petitioner's rights, but was also aware of the almost overwhelming evidence against petitioner. His devotion to petitioner's cause is amply demonstrated by the evidence…The facts surrounding the death of Branch as related to [the attorney] by petitioner presented a clear case of murder under Mississippi law. [The attorney's] conferences with members of petitioner's family confirmed that petitioner had given his family the same version of the facts. It should also be remembered that certain unidentified members of petitioner's family were present at the scene of the killing. It is not unreasonable to assume that those members of petitioner's family told what they knew either to [the attorney] or to the other members of the family. It is significant that [the attorney's] interviews with the family produced no conflicts with the version of the facts related to [the attorney] by petitioner. [The attorney's] conversations with the state's attorneys further confirmed petitioner's version of the facts. There is nothing before this court to indicate that even if [the attorney] had interviewed other witnesses he would have learned anything different from what he was told by petitioner, petitioner's family and the state's attorneys. It is possible, indeed likely, that some attorneys in the same circumstances might have interviewed other witnesses. However, in the absence of a showing that [the attorney's] failure to interview such witnesses resulted in his being unaware of available evidence which could have been used to the benefit of petitioner, the court is of the opinion that such failure did not render [the attorney's] assistance to petitioner ineffective.

35

333 F.Supp. at 1040-1041.

36

Finally, even in the calm of retrospect we do not fault counsel's advice that Winters should plead guilty in exchange for a lesser penalty. Lawyers worth their salt acutely feel the oppressive weight of professional responsibility when it must carry the stake of human life. If the jury exclusion claim had been successfully asserted, it would have at most only postponed the day of the final judgment. On the facts of this case, we cannot say any able defense lawyer would have made or should have allowed a client to make a

APPENDIX II

different decision. Even ignoring the racial overtones which the dissenters emphasize as so important to this time and place for procedural purposes, Winters' exchange of a lethal shotgun blast for a prior verbal insult and a fisticuff makes his lawyer's trade of a term of imprisonment which could be as short as ten years for the chance to gamble on the death sentence look like a sure thing. But conceding arguendo, that the attorney was mistaken in his decision not to attack the jury composition, surely that judgment was well 'within the range of competence demanded of attorneys in criminal cases.' *McMann v. Richardson*, supra.

37

The judgment of the district court is Affirmed.

38

RIVES, Senior Circuit Judge, dissenting, with whom JOHN R. BROWN, Chief Judge, concurs in part, and GOLDBERG, Circuit Judge, concurs:

39

With deference I dissent and adhere to the majority holding of the original panel (466 F.2d 1393 at 1397) reversing and remanding this case for an evidentiary hearing on the issue of whether Negroes were in fact systematically excluded from grand and petit juries in Holmes County, Mississippi, at the time of Winters' indictment and conviction. I respectfully submit:

40

(1) that the unilateral action of his counsel does not bar Winters from seeking relief based on systematic exclusion of Negroes from either the grand or petit jury;

41

(2) that Winters' guilty plea was not voluntary and intelligent;

42

(3) that Winters was not furnished effective assistance of counsel;

43

(4) that *Goldsby* (263 F.2d 71) should remain fully applicable in jurisdictions like Holmes County, Mississippi.

44

The four issues just outlined are so overlapping and mutually interlocking that they can best be discussed together.

45

The population of Holmes County, Mississippi, is about 70% black and 30% white. We, of course, take judicial notice of the census figures. According to the 1960 Census, Holmes County had 2218 white males

Appendix II

and 3913 nonwhite males (Winters' habeas petition averred that 99% of those listed nonwhite were Negroes). According to the 1970 Census, Holmes County had a total population of 23,120 of which 15,743 were Negroes, 68% of the total. Thus, for every seven Negroes there were approximately three white persons in Holmes County. Yet Winters' federal habeas petition averred that 'at the time of the indictment of the petitioner, either no Negroes or only a very small percent had ever been on the jury list.' (App. p. 8.) At each step of his post-conviction proceedings in the state court and in the federal court, Winters has consistently attacked the petit jury array as well as the grand jury composition (see App. pp. 4, 6, 7, 11 to 16). He has never had an opportunity to prove that Negroes were in fact systematically excluded from either the grand jury or the petit jury. This appeal should be decided upon the assumption that, if afforded that opportunity, Winters might be able to prove the truthfulness of his averments.

46

Certainly this Court cannot proceed on the assumption upon which Winters' attorney acted; namely, that the racial composition of the jury made no difference. 'I have always assumed that jurors try the facts.' (App. p. 90, see also App. pp. 86-87.) For the Court to proceed upon such an assumption would be wholly unrealistic and would amount to holding unnecessary all of that long line of jurisprudence forbidding systematic exclusion of persons from jury service because of their race. Indeed, Mr. Crawley misconceived his role as an advocate for Winters as opposed to that of amicus curiae.

47

The racial composition of the juries, grand and petit, was of utmost importance because the case literally shrieks with racial overtones. Branch, a middle-aged white man with a bad reputation in the community, severely slapped Winters, an 18-year-old Negro, because Winters talked to a Negro girl employee in Branch's beer joint. Infuriated by the slap, Winters left the beer joint, drove to get a shotgun, and returned to kill Branch.

48

Perhaps we can better envision the case if in our mind's eye we picture it as one in which the races of the parties are reversed. That is to say, a middle-aged black man with a bad reputation in the community runs a beer joint in which he employs a white girl. A white boy, 18 years old, undertakes to talk to the girl and the black man severely slaps the white boy. The white boy, infuriated by the slap, leaves the beer joint, drives to get a shotgun, and returns to kill the black man. Would any member of this Court be so

Appendix II

certain that the white boy would suffer the death penalty unless he entered a bargained plea for a life sentence? Would it be certain that the white boy would be indicted for murder? Would it be fair for that white boy to be indicted for murder by an all-black grand jury and to be tried before an all-black petit jury with whites systematically excluded from jury service? Certainly not. Before this Court, Winters stands on an equal footing with that white boy. Each is entitled to a trial before a jury of his peers from which members of his race have not been systematically excluded.

49

There could scarcely exist a clearer or more extreme case in which an attorney undertook to act unilaterally, without consulting or advising his client as to his rights or as to the pertinent facts to be considered in reaching a decision to plead guilty or not guilty. That is shown by the following express and detailed findings of fact made by Judge Keady, the federal district judge; quoted in the margin. However well-intentioned he may have been, Mr. Crawley wholly misconceived his role as attorney for Winters. In reaching a decision to change his plea to guilty and accept life imprisonment as punishment, Winters was entitled to the advice of his attorney, not to his virtual dictation. Mr. Crawley simply had no right or authority to assume the ultimate responsibility for Winters' destiny.

50

Winters was not lacking in intelligence. That is readily demonstrated from reading his testimony before the state trial judge at the hearing of his motion to vacate (App. 59-78). Judge Keady found as a fact that, 'Although lacking in formal education, petitioner was intelligent and capable of normal understanding.' (333 F.Supp. 1036).

51

The right and responsibility to reach the ultimate decision as to pleading guilty or not rested squarely upon the shoulders of Winters himself. Winters was denied that right.

52

In Developments in the Law—Federal Habeas Corpus, 83 Harv.L.Rev. 1038, 1110, the author states:

53

'Any attempt to devise a waiver rule independent of the allocation of authority between attorney and client in the trial court is doomed to failure. The waiver question requires a determination as to which of the two may act authoritatively in the proceedings looking to a final judgment of guilt or innocence.'

Appendix II

54

In a classic affirmation of the need for the defendant's personal participation in a significant by-pass decision, the Supreme Court stated in *Fay v. Noia*, 1962, 372 U.S. 391, 438–439, 83 S.Ct. 822, 849, 9 L.Ed.2d 837:

55

'We therefore hold that the federal habeas judge may in his discretion deny relief to an applicant who has deliberately by-passed the orderly procedure of the state courts…

56

'But we wish to make very clear that this grant of discretion is not to be interpreted as a permission to introduce legal fictions into federal habeas corpus. The classic definition of waiver enunciated in *Johnson v. Zerbst*, 304 U.S. 458, 464 (58 S.Ct. 1019, 82 L.Ed. 1461)—'an intentional relinquishment or abandonment of a known right or privilege'—furnishes the controlling standard…At all events we wish it clearly understood that the standard here put forth depends on the considered choice of the petitioner…A choice made by counsel not participated in by the petitioner does not automatically bar relief.'

57

The clear mandate of the *Noia* standard is that the defendant must personally participate in the by-pass decision. The admonition in the last sentence does little to undermine the strength of the standard dictated by the entire paragraph.

58

The key question is to what extent, if any, does *Henry v. Mississippi*, 1965, 379 U.S. 443, 85 S.Ct. 564, 13 L.Ed.2d 408, limit the broad language of *Noia* emphasizing the need for defendant's personal participation in the by-pass decision.

59

The majority recognizes, as it must, that after *Henry* there are instances where a defendant's personal waiver is required. According to the majority, those instances fall into two categories: First, where there is evidence of incompetence on the part of the defendant's attorney; and, second, where an inherently personal right of fundamental importance is involved.

60

In the original panel opinion, the majority held that Winters' guilty plea was not intelligently entered and, hence, any waiver incorporated in that plea was ineffective. That holding rendered academic the issue of Crawley's right to independently waive Winters' potential jury objection. I adhere to the view that Winters' conviction should be reversed on the ground that

his guilty plea was constitutionally invalid, but assuming arguendo that the plea was competent, I would hold, in contrast to the majority, that the right to racially nondiscriminatory grand and petit juries is so important as to require a personal waiver.

61

The majority's rhetorical statements that 'We refuse to enlarge the attorney's duty to include the responsibility to inform the defendant of every possible constitutional claim' and 'A lawyer does not have to conduct a course in constitutional law for his client to validly discharge his position of trust' tend to obscure the real issue involved—whether the constitutional right to racially nondiscriminatory grand and petit juries is one of those paramount rights which must be personally waived by the defendant.

62

For almost a century the Supreme Court has consistently held that 'a conviction cannot stand if it is based on an indictment of a grand jury or the verdict of a petit jury from which Negroes were excluded.' *Whitus v. Georgia*, 1966, 385 U.S. 545, 549, 87 S.Ct. 643, 646, 17 L.Ed.2d 599. In view of the Supreme Court's emphatic sustained confirmation of the constitutional right to racially nondiscriminatory grand and petit juries, I submit that that right is far too important to be taken out of the defendant's hands.

63

The majority places great weight upon the following language in *Henry*, supra at 451-452, 85 S.Ct. 564, 569:

64

'Although trial strategy adopted by counsel without prior consultation with an accused will not, where the circumstances are exceptional, preclude the accused from asserting constitutional claims, see *Whitus v. Balkcom*, 333 F. 2d 496 (5th Cir. 1964), we think that the deliberate by-passing by counsel of the contemporaneous-objection rule as a part of trial strategy would have that effect in this case.'

65

In spite of the Supreme Court's explicit reference to *Whitus v. Balkcom* as an example of 'exceptional circumstances,' the majority concludes that the present case does not fall within the 'exceptional circumstances' portion of the *Henry* rule. With that conclusion, I categorically disagree.

66

In *Whitus v. Balkcom*, this Court recognized the 'Hobson's choice' imposed upon both a black defendant and his white attorney in jurisdictions with a history of racial segregation and an all-white jury system:

Appendix II

67

'But the burden is exceptionally heavy when the life and liberty of an accused depend on the weight to be given something as imponderable as the extent of the additional anti-Negro reaction that would be engendered by attacking the all-white jury system. As if this were not sufficiently difficult, there is the intolerable complication that the reaction against an attorney who raises the exclusion issue may stretch from persiflage to ostracism.'

68

Whitus, supra, 333 F.2d at 505, 506. Thus, there are two Hobson's choices—one faced by the black defendant and the other by his white attorney. The majority ignores completely the constitutionally impermissible choice forced upon the black defendant, ruling only on the issue of the attorney's Hobson's choice:

69

'The majority of the court en banc now announces that it does not consider such breach of trust by counsel (referring to the judicial notice taken in *Goldsby v. Harpole* that southern lawyers rarely raise the issue of systematic exclusion of Negroes from juries) to be so prevalent in any jurisdiction of this circuit that this court should, in the absence of proof, place all or even some lawyers in this circuit under the cloud of such an accusation.'

70

Assuming that the majority's prospective overruling of *Goldsby* and disclaimer of any 'Hobson's choice' facing modern southern lawyers is correct (a conclusion I do not accept), the principal Hobson's choice—that imposed upon the black defendant himself—which was recognized in *Goldsby* (see 263 F.2d 82) and formed the heart of the Court's reasoning in *Whitus*—certainly faced Winters in Holmes County, Mississippi in 1963. The key to the holding in *Goldsby* and in *Whitus*, the unconstitutional burden shouldered by the accused, endures as an 'exceptional circumstance' specifically recognized by the Supreme Court in *Henry*. The probity of the black defendant's white attorney, the issue with which the majority is preoccupied, is irrelevant to the central thrust of the 'exceptional circumstances' rule. Even assuming that the waiver of the constitutional claim is calculated to benefit the defendant, if the advantage to be gained by the waiver is the avoidance of improper racial prejudice, then the attorney's decision will not bind the defendant.

71

To obviate what appears to me to be mistaken reliance by the majority on *Tollett v. Henderson*, 1973, 411 U.S. 258, 93 S.Ct. 1602, 36 L.Ed.2d 235, I quote the conclusion reached by Mr. Justice Rehnquist:

72

'We thus reaffirm the principle recognized in the *Brady* trilogy: a guilty plea represents a break in the chain of events which has preceded it in the criminal process. When a criminal defendant has solemnly admitted in open court that he is in fact guilty of the offense with which he is charged, he may not thereafter raise independent claims relating to the deprivation of constitutional rights that occurred prior to the entry of the guilty plea. He may only attack the voluntary and intelligent character of the guilty plea by showing that the advice he received from counsel was not within the standards set forth in *McMann*.'

73

411 U.S. 258, 267, 93 S.Ct. 1602, 1608, 36 L.Ed.2d 235, 243.

74

Thus the issue is now precisely drawn: When Winters pleaded guilty, was the advice he received from counsel 'within the range of competence demanded of attorneys in criminal cases'? I submit that that question should be answered in the negative.

75

Winters was ignorant both as to the constitutional invalidity of the indictment and as to his prospects for a fair trial before a jury of his peers from which members of his race were not systematically excluded. Mr. Crawley was fully aware of Winter's rights and of their prospective violation in a trial on the merits, but he failed completely to give Winters any advice whatsoever on the subject. Thus Winters was denied effective assistance of counsel.

76

Mr. Justice Rehnquist pointed out that in the *Brady* trilogy the facts giving rise to the constitutional claims were generally known both to the defendants and to their attorneys prior to the entry of the guilty pleas, and that in *Tollett* such facts were unknown both to the defendant and to his attorney. Here the facts were known to Mr. Crawley but they were not known to Winters. This case differs from both the *Brady* trilogy and *Tollett* in that here the defendant's attorney was under a positive duty to advise the defendant of his constitutional rights and that in the absence of objection those rights would be violated. Mr. Crawley completely, indeed deliberately, failed to give Winters any such advice. Thus Winters was denied effective assistance of counsel.

77

Further, it is plain error for a trial court to accept a plea of guilty without an affirmative showing that the defendant himself intelligently and voluntarily entered his plea. *Boykin v. Alabama*, 1969, 395 U.S. 238, 242,

Appendix II

89 S.Ct. 1709, 23 L.Ed.2d 274. 'What is at stake for an accused facing death or imprisonment demands the utmost solicitude of which courts are capable in canvassing the matter with the accused to make sure he has a full understanding of what the plea connotes and of its consequence.' *Boykin*, supra, 395 U.S. at 243-244, 89 S.Ct. 1709, 1712. The voluntariness of the plea 'can be determined only be considering all of the relevant circumstances surrounding it.' *Brady v. United States*, 1970, 397 U.S. 742, 749, 90 S.Ct. 1463, 1469, 25 L.Ed.2d 747. A plea of guilty waives the defendant's constitutional right to trial. Such a waiver not only must be voluntary but must be a knowing, intelligent act done with 'awareness of the relevant circumstances and likely consequences.' The defendant must have an opportunity to make 'an intelligent assessment of the relative advantages of pleading guilty,' *Brady*, supra, 397 U.S. at 748 n. 6, 90 S.Ct. at 1469, and to 'rationally weigh the advantages of going to trial against the advantages of pleading guilty,' *Brady*, supra, 397 U.S. at 750, 90 S.Ct. at 1470.

78

From the record in this case, one must conclude that Winters' attorney refrained from giving him any advice as to Winters' right to challenge the racial composition of both the grand jury and the trial jury. Being ignorant of such matters, and with his attorney deliberately failing to give him any pertinent advice, it was simply impossible for Winters to make an intelligent choice to change his plea from not guilty to guilty.

79

I conclude that Winters' guilty plea was not valid; he was not furnished effective assistance of counsel; the unilateral action of his counsel was not a waiver by Winters; *Goldsby* should remain fully applicable in jurisdictions like Holmes County, Mississippi.

80

I respectfully dissent.

81

GODBOLD, Circuit Judge, dissenting, with whom JOHN R. BROWN, Chief Judge, and WISDOM, Circuit Judge, concur:

82

The Supreme Court, in *Henry v. Mississippi*, 379 U.S. 443, 85 S.Ct. 564, 13 L.Ed.2d 408 (1965), recognized that under exceptional circumstances trial strategy adopted by counsel without prior consultation with the accused will not preclude the accused from later constitutional claims. In the opinion for the Court Justice Brennan cited the decision of this circuit in *Whitus*

Appendix II

v. Balkcom, 333 F.2d 496 (5th Cir., 1964, as an example of 'exceptional circumstances.' 379 U.S. at 451, 85 S.Ct. at 569, 13 L.Ed.2d at 415. In *Whitus*, Judge Wisdom's opinion for this court had addressed itself to, inter alia, the 'Hobson's choice' imposed upon the white attorney for a black defendant in places where as a consequence of past practices of segregation there has been an all-white jury system. 333 F.2d at 505-509. The teaching of *Whitus* in this respect is not that an attorney who does not question the racial composition of the jury is necessarily lacking in competence or is failing to conscientiously represent his client. Rather it is that the defendant is prejudiced in a constitutional sense when his counsel, however, able and conscientious, is presented with such a 'Hobson's choice.'

83

In this case I do not fault counsel nor do I question the bona fides of his conclusion that the case against his client was such that he considered the racial composition of the jury to be immaterial. But those considerations do not solve the constitutional issue. To cite the conclusion conscientiously made by counsel who knows the facts about the jury system, or to conclude that faced with the possibility of a 'Hobson's choice' he secured a good plea bargain for his client, is no answer to the principle that the constitution forbids that the choice be injected into the case in the first instance.

84

The majority opinion gives lip service to the interplay of *Henry* and *Whitus* but undercuts it. There can be little doubt that Holmes County is a place where as a consequence of past practices there has been racial exclusion of Negroes from juries. Winters' counsel, on the scene, recognized this and elected to employ it as a lever in plea bargaining. I do not understand the majority to deny the past history of racial exclusion but rather to confess and avoid. One prong of the avoidance is that viewed in retrospect Winters' counsel made effective use of the very deficiency of which Winters now complains. The difficulty with this approach—that Winters really got a 'good deal' and ought not to complain— is that had Winters been informed of the racial exclusion point he might have elected to stand on it and take his chances before a properly constituted jury. While we do not know, he just might have been acquitted or convicted of some lesser offense. He was deprived of participation in the decision as to what election to make, and that deprivation cannot be cured by the subsequent reaction of judges that, considering all, he came out remarkably well.

85

The theory, asserted to avoid *Whitus*, that as to the petit jury Winters' attorney never faced the 'cruel choice' because he made a plea bargain before a

Appendix II

trial court convened, will not stand examination. The possible assertion of racial composition of Holmes County juries was the springboard for plea bargaining. The matter of whether—and how—racial composition would be raised if no plea bargain was agreed upon necessarily was a factor in counsel's decisional process. The ultimate moment of truth never came, but it would have arisen had there been no plea bargain. The 'Hobson's choice' may not be inflicted either in the courtroom at trial, or ahead of trial as a factor necessarily part and parcel of plea bargaining.

86

The second prong of the majority's confession and avoidance is to conclude that this is not an 'exceptional circumstance' case within *Henry v. Mississippi*. Necessarily my brothers must draw the teeth of Justice Brennan's reference in *Henry* to *Whitus* as an example of 'exceptional circumstances.' In *Whitus*, a waiver-by-counsel case, there was a history of racial exclusion of Negroes from juries to which was applied the 'judicial notice' rule of *Goldsby v. Harpole*, 263 F.2d 71 (5th Cir.), cert. denied, 361 U.S. 850, 80 S.Ct. 109, 4 L.Ed.2d 89 (1959). The majority in the present case, therefore, recede from *Goldsby* and would require the client whose right to object to racial composition of a jury has been waived by his counsel, to prove that in waiving without the client's consent the attorney failed in his obligation. (Presumably there would be failure of obligation if it could be shown that the attorney was unwilling to raise the issue of racial exclusion or that the possibility of having to raise the issue was a significant factor in the plea bargaining process.)

87

The majority do not say that *Goldsby* was wrong ab initio. Indeed a group of judges none of whom was on this court in 1959, and most of them not even on the bench, are hardly in position to say that JJ. Rives, Brown (now Chief Judge) and Wisdom, erred in 1959 in considering particular subject matter to be of such general currency at that time as to be accepted as true without proof. The principle then established in *Goldsby* was not one of universal application but rather by its own terms was limited to 'many jurisdictions.' It is possible that in some places where past segregation practices once commanded the application of *Whitus-Goldsby* time and change have so erased history that the choice—faced by counsel knowing the facts—of whether to attack the racial composition of the jury is no longer a choice between the lesser of two evils. But it is for the state to prove by objective facts that the particular jurisdiction is not one of the 'many jurisdictions' in which *Goldsby* applies. That was not done here. It strikes me as inappropriate to wipe out an established rule having specialized application throughout the range of a giant six-state circuit by

means of a sweeping pronouncement in a case in which the concern is racial exclusion in a single county in one state, and to do this without objective facts.

88

The defendant in this case pleaded guilty, while the defendants in *Henry* and *Whitus* had been found guilty after trial. The majority opinion refers to *Tollett v. Henderson*, 411 U.S. 258, 93 S.Ct. 1602, 36 L.Ed.2d 235 (1973), holding that a state criminal defendant who had pleaded guilty could not thereafter raise by federal habeas corpus a cliam [sic] of racially-related infirmity in the grand jury selection process. In *Tollett* the Court stated that the counselled [sic] defendant who has entered a guilty plea 'may only attack the voluntary and intelligent character of the guilty plea by showing that the advice he received from counsel was not within the standards set forth in *McMann* (*McMann v. Richardson*, 397 U.S. 759, 770-771, 90 S.Ct. 1441, 25 L.Ed.2d 763, 773 [1970]), which stated that the test is whether the advice was within the range of competence demanded of attorneys in criminal cases).' But in *Tollett*, neither the petitioner nor his counsel knew how the grand jury had been selected, or that Negroes were systematically excluded. 411 U.S. 258, 93 S.Ct. 1602, 36 L.Ed.2d at 239. *Tollett*'s complaint was not that his attorney had been faced with an unconstitutional 'Hobson's choice' but rather that he had failed to make diligent inquiry to ascertain the facts concerning racial exclusion, an issue which the court left open to be determined on remand under *McMann* standards. It seems to me that *Tollett* has no application to the situation where counsel does know of the all-white jury system and is thrust eyeball-to-eyeball against the cruel choice described in *Whitus*.

89

One of the reasons that the 'Hobson's choice' of *Whitus* was an 'exceptional circumstance' under *Henry* is the risk that against a background of historical exclusion of blacks from the jury the white attorney will fail to confer with and advise his black client about attacking the system, or, if the attorney does confer with him, that the advice may be colored by counsel's fear of harm to his client's cause or his concern (conscious or unconscious) for his own status in the community. *Whitus*, supra, 333 F.2d at 505-506. It makes no sense to apply *McMann*'s standards of competence to a situation which respect to which the Supreme Court has recognized that the risks to the defendant are independent of counsel's competence. Thus, the *Whitus-Henry* combination remains viable where—or, more specifically, at the very least where—the complaint is not that counsel does not know enough but that he knows so much that the risks to his client are too great.

JOHN R. BROWN, Chief Judge (dissenting):

Appendix II

90

As one of the original panel, I adhere to reversal. I therefore dissent, but I think we should have put this result on the ground of *Whitus-Henry* exceptional circumstances which Judge Godbold so well articulates in his dissent in which I join. I also join in Judge Rives' opinion as to this ground. This ground is so clear to me that I do not have to consider the other grounds argued by Judge Rives for reversal.

91

For such a 'Hobson's choice' minimal assistance requires that the lawyer counsel with the accused, carefully and fully explaining the legal issues and the choices open. The choice may still be a 'Hobson's choice,' but the choice is that of the accused, not that of the lawyer.

1

Particularly is this true where, as here, the defendant is illiterate. On facts somewhat similar to the ones in the case at hand, this court has said:

> It is unrealistic for this court to attach significance to the presence or absence of consultation of the attorneys with the defendants and the presence or absence of express consent by the defendants to the so-called waiver.

Whitus v. Balkcom, 333 F.2d 496, 503 (5th Cir.), cert. denied, 379 U.S. 931, 85 S.Ct. 329, 13 L.Ed.2d 343 (1964). See also *Cobb v. Balkcom*, 339 F.2d 95, 101 (5th Cir. 1964).

2

Here Winters has made no showing at all that the attorney's decision was in any way motivated by other than a desire to save his client's life. Indeed, what evidence there is more refutes than proves any contention that the attorney refrained from challenging the grand jury out of a fear of social, extralegal pressures. The district attorney, an elected official much more sensitive to community reaction than petitioner's attorney, was persuaded by the attorney's willingness to use this possible defense to intercede with the court for a guilty plea and a prison term sentence in an easy-to-prove case of coldblooded interracial murder

3

An examination of reported decisions of the Mississippi Supreme Court reveals that such objections were not uncommon in Mississippi courts prior to petitioner's guilty plea. *Gibson v. State*, Miss., 17 So. 892 (1895), aff'd, 162 U.S. 565, 16 S.Ct. 804, 40 L.Ed. 1075 (1896); *Smith v. State*, Miss., 18 So. 116 (1895), aff'd, 162 U.S. 592, 16 S.Ct. 900, 40 L.Ed. 1082 (1896); *Williams v. State*, Miss., 20 So. 1023 (1896), aff'd, 170 U.S. 213, 18 S.Ct. 583, 42 L.Ed. 1012 (1898); *Dixon v. State*, Miss., 74 Miss. 271, 20 So. 839 (1896); *Lewis v.*

Appendix II

State, 91 Miss. 505, 45 So. 360 (1908); *Farrow v. State*, 91 Miss. 509, 45 So. 619 (1908); *Pearson v. State*, 176 Miss. 9, 167 So. 644 (1936); *Moon v. State*, 176 Miss. 72, 168 So. 476 (1936); *Patton v. State*, 201 Miss. 410, 29 So.2d 96, rev'd, 332 U.S. 463, 68 S.Ct. 184, 92 L.Ed. 76 (1947); *Gipson v. State*, 203 Miss. 434, 35 So.2d 327, 36 So.2d 154 (1948); *McGee v. State*, 207 Miss. 120, 40 So.2d 160 (1949), cert. denied, 338 U.S. 805, 70 S.Ct. 77, 94 L.Ed. 487 (1950); *Flowers v. State*, 209 Miss. 86, 41 So.2d 352 (1949), cert. denied, 339 U.S. 946, 70 S.Ct. 800, 94 L.Ed. 1360 (1950); *Ferrell v. State*, 208 Miss. 539, 45 So.2d 127 (1950); *Seay v. State*, 212 Miss. 712, 55 So.2d 430 (1951); *Durr v. State*, 214 Miss. 658, 59 So.2d 304 (1952); *Wheeler v. State*, 219 Miss. 129, 63 So.2d 517, cert. denied, 346 U.S. 852, 74 S.Ct. 67, 98 L.Ed. 367 (1953); *Johnson v. State*, 223 Miss. 56, 76 So.2d 841, cert. denied, 349 U.S. 946, 75 S.Ct. 874, 99 L.Ed. 1272 (1955); *Walker v. State*, 229 Miss. 540, 91 So.2d 548 (1956); *Cameron v. State*, 233 Miss. 404, 102 So.2d 355 (1958); *Kennard v. State*, 242 Miss. 691, 128 So.2d 572, cert. denied, 368 U.S. 869, 82 S.Ct. 111, 7 L.Ed.2d 66 (1961); *Gordon v. State*, 243 Miss. 750, 140 So.2d 88 (1962); *Wilson v. State*, 243 Miss. 859, 140 So.2d 275 (1962); *Harper v. State*, 251 Miss. 699, 171 So.2d 129 (1965) (trial occurred on March 11, 1963).

The reports further indicate that in the years immediately succeeding petitioner's plea such challenges were even more frequent. Moreover, it is practically certain the number of times such challenges or the active use of the leverage of such a position by defense counsel took place in unreported trial court situations is much, much greater. For example, the Mississippi Supreme Court, in refusing *Goldsby*'s state court collateral attack on his conviction, noted that counsel for one of *Goldsby*'s codefendants timely made such a challenge to the grand jury. *Goldsby v. State*, 226 Miss. 1, 86 So.2d 27, 31 (1956).

4

I take this opportunity to correct a confusing error in footnote 2 to my dissent to the original panel decision in this case, 466 F.2d at 1399. The footnote should conclude 'it is not inappropriate to note that in *Goldsby* and [other] of the cases examined, the defense was effectively raised, but the defendant was eventually executed after retrial with a proper jury. A Pyrrhic victory indeed.' (Corrected word in brackets.) This reference to *Goldsby*'s execution and the execution of several of those more-than-twenty referred to in that footnote who initially raised their jury claim in the state courts was not intended to fault the *Goldsby* court's reasoning by hindsight. It merely suggests that no one can quarrel with the forceful truth forecast by the results of those cases had Winters' attorney chosen to submit his case to a jury in

Appendix II

order to formally raise the constitutional claim. A motion won is a poor exchange for a client's life lost.

1
United States v. Gottfried, 2nd Cir. 1948, 165 F.2d 360, 363, cert. denied, 333 U.S. 860, 68 S.Ct. 738, 92 L.Ed. 1139, reh. denied, 333 U.S. 883, 68 S.Ct. 910, 92 L.Ed. 1157; 22A C.J.S. Criminal Law 541(2), p. 258

2
See *Ellis v. United States*, 1958, 356 U.S. 674, 78 S.Ct. 974, 2 L.Ed.2d 1060; *Anders v. California*, 1967, 386 U.S. 738, 744, 745, 87 S.Ct. 1396, 18 L.Ed.2d 493; *Entsminger v. Iowa*, 1967, 386 U.S. 748, 751, 87 S.Ct. 1402, 18 L.Ed.2d 501

3
The only evidentiary hearing was that in the state trial court on Winters' motion to vacate, and the only evidence as to the facts and circumstances of the killing was the hearsay testimony of Mr. Crawley as to what Winters had told him. Mr. Crawley testified to different, if not inconsistent, versions on direct examination (App. 81, 82) and on re-direct examination (App. 97). Judge Keady adopted the latter version: 'A total distance of approximately 40 Miles had been traveled from the beer joint to the friend's house and back' (333 F.Supp. 1037). Forty miles travel by automobile would probably consume less than an hour in time. Under Mississippi law, it would be for the jury to say whether there had been sufficient time for cooling of Winters' feelings of outrage to furnish the 'malice aforethought' essential for a conviction of murder, and consequently whether the crime amounted to murder or manslaughter. In a case where the state of agitation extended from Monday night until Wednesday afternoon, the Mississippi Supreme Court said: 'There is no fixed period of time for cooling. Whether there has been time for cooling and malice engendered depends upon the circumstances, and sometimes upon the temperament of the defendant on trial.' *Haley v. State*, 1920, 123 Miss. 87, 85 So. 129, 132. Title 11, 2226 of the Mississippi Code states that, 'The killing of another in the heat of passion, without malice, by the use of a dangerous weapon, without authority of law, and not in necessary self-defense, shall be manslaughter.'

4
'Mr. Crawley was aware of petitioner's right to attack the exclusion of Negroes from the grand jury which indicted him and from the petit jury impaneled for the October term of the Circuit Court of Holmes County.' 333 F.Supp. 1038

'He [Mr. Crawley] did not advise petitioner's family of petitioner's right to challenge the racial composition of the juries.' 333 F.Supp. 1038.

Appendix II

'At no time did Mr. Crawley advise petitioner that he had a right to challenge the racial composition of either the grand jury or the petit jury.' 333 F.Supp. 1039.

'At no time did either petitioner's attorney or the state court advise petitioner of his right to challenge the racial composition of either the grand or petit juries, and petitioner was not aware of that right.' 333 F.Supp. 1040.

'An apt illustration of Mr. Crawley's view of his duties and responsibilities as petitioner's defense counsel is the following excerpt from the cross-examination of Mr. Crawley by petitioner's attorney in the evidentiary hearing held on the motion to vacate sentence in the Circuit Court of Holmes County:

> *Q. You did not file a motion to quash the indictment prior to arraignment?*
> *A. No, I did not.*
> *Q. Did it occur to you that under Mississippi law, you might have waived the defendant's right to object on the grounds of systematic exclusion of Negroes as jurors?*
> *A. I was aware that any motion must be filed before arraignment. I was also aware that in view of the seriousness of the constitutional questions that could be raised, that it would be reversible error for the court to overrule the motion, probably. 'Mr. Fitzgerald,' the supreme thing in my mind at the time was saving this man's life. I felt then and now that I must do and did do at that time all I could to save this man from the death penalty.*
> *Q. Were you concerned with whether or not you were making the decision your client would have made?*
> *A. Well, insofar as making decisions are concerned, I accepted the responsibility of this man's destiny when I accepted employment. I was representing him to the best of my ability, and I cannot say I would have allowed him to make any decision which I felt would put his life in jeopardy. Before I could do that, I would have asked the court to allow me to withdraw, I could not knowingly allow him to make a decision which would put his life in jeopardy.*
> *Q. But it went a little deeper than that because you did not inform him of what his rights were, did you, as to the composition of the jury?*
> *A. Insofar as his constitutional rights with regard to the composition of the Grand and Petit Juries, I did not discuss that with him, as I say, I was more concerned with saving this man's life than anything else. 333 F.Supp. 1039, n. 4.*

Appendix II

5

See also *Strauder v. West Virginia*, 1879, 100 U.S. 303, 25 L.Ed. 664; *Pierre v. Louisiana*, 1939, 306 U.S. 354, 59 S.Ct. 536, 83 L.Ed. 757; *Peters v. Kiff*, 1972, 407 U.S. 493, 92 S.Ct. 2163, 33 L.Ed.2d 83; *Alexander v. Louisiana*, 1972, 405 U.S. 625, 92 S.Ct. 1221, 31 L.Ed.2d 536; where the Court stressed the importance of a racially balanced grand jury, independent of the petit jury issue.

6

It is important to note that *Henry* involved a situation requiring an immediate courtroom decision. The logical conclusion to be drawn from the facts in *Henry* is that *Henry* eliminates the requirement of personal participation only as to decisions involving ongoing courtroom tactics. This interpretation is buttressed by the fact that *Henry* made no mention of limiting *Noia*, and Mr. Justice Brennan wrote both opinions. *Noia* involved a nontrial issue—the right to appeal, whereas *Henry* involved a trial issue—admission of a police officer's damaging testimony. This case falls within that class involving nontrial strategy to which the *Noia* mandate applies.

In *Brookhart v. Janis*, 1966, 384, U.S. 1, 86 S.Ct. 1245, 16 L.Ed.2d 314, a habeas case, decided during the term following *Henry*, the Supreme Court found that the petitioner's alleged waiver of the right to cross-examine witnesses by agreeing to let the state prove merely a prima facie case did not meet the standards of *Johnson v. Zerbst*, 304 U.S. 458, 58 S.Ct. 1019, 82 L.Ed. 1461, since petitioner obviously did not appreciate the significance of counsel's agreement to accept proof of a 'prima facie' case. In holding that petitioner's right to confrontation could not be waived by counsel, the Court found 'nothing in *Henry*' that could 'possibly support' a contrary result. Winters, like the petitioner in *Brookhart*, gave up his right to trial and confrontation by succumbing to a bargain (struck by counsel) whose significance Winters did not appreciate. In *Brookhart*, as in *Noia* and Winters, there was time for the attorney to advise his client; a *Henry*-type courtroom tactical decision was not involved.

7

In order to reach the conclusion that the second leg of the *Whitus* holding is now incorrect, the majority finds it necessary to prospectively repudiate this Court's statement in *Goldsby* that, 'As Judges of a Circuit comprising six states of the deep South, we think that it is our duty to take judicial notice that lawyers residing in many southern jurisdictions rarely, almost to the point of never, raise the issue of systematic exclusion of Negroes from juries.' (263 F.2d at 82.) That quotation was lifted out of context. The quotation had been preceded by a long paragraph showing the prejudicial effect on

Appendix II

the defendant himself caused by raising the issue. See *Goldsby v. Harpole*, 263 F.2d at 82. The judicial notice taken in *Goldsby* was judicial notice of a legislative fact, not an adjudicative fact, see Judicial Notice, 55 Colum.L.Rev. 945 (1955); K. Davis, Administrative Law Treatise 15.03 (1958); Note, 72 Yale L.J. 559 (1963); and as a crucial link in the Court's reasoning process, it was perfectly proper. The majority's citation of Mississippi Supreme Court decisions which involved jury discrimination objections made prior to *Goldsby* does not undermine the fact that in many southern jurisdictions such objections were rare. Happily the number of such jurisdictions is now much less, but in predominantly Negro jurisdictions like Holmes County, Mississippi, the battle has not been won.

A few quotations from cases decided in this Circuit will reveal actual testimony supporting the position taken in *Goldsby*. Winters' attorney, Mr. Crawley, testified that although he has represented many Negro defendants, 'He had never filed such a challenge himself, but knew of one case in which a white attorney had challenged the composition of a jury on racial grounds in Kosciusko, without adverse social or economic effects.' 333 F.Supp. at 1037. 'Honorable Carl Booth, who had been the State prosecuting attorney in Mobile since 1943, testified that no motion based on the exclusion of Negroes from the grand jury or the petit jury had ever been made prior to Seals' trial.' U.S. ex rel. *Seals v. Wiman*, 5 Cir. 1962, 304 F.2d 53, 68. 'Mr. Johnson, the attorney who represented Seals on his trial, testified that he had defended many other Negroes for capital crimes, somewhere between fifteen and fifty, but that he never had a Negro as one of the jurors in a capital case in which a Negro was a defendant. He had never attacked the composition of a jury on the ground that Negroes were systematically excluded.' U.S. ex rel. *Seals v. Wiman*, 304 F.2d at 68. 'The evidence adduced in support of the petition included sworn statements of the sheriff and deputy clerk of the Superior Court of Jasper County, who had held their positions, respectively, for 21 and 30 years, that no Negroes had ever served on a grand or traverse jury in the county during the past 30 years…These officials stated also that they had never heard counsel for a Negro defendant in a criminal case raise any constitutional objection to the composition of a jury panel from which the names of grand and traverse jurors were drawn.' *Cobb v. Balkcom*, 5 Cir. 1964, 339 F.2d 95, 98. 'The affidavit of Cobb's trial counsel showed that he had been a member of the Georgia Bar since 1934; that he had defended many Negroes charged with felonies in the county, and that he had never seen a Negro serving on a traverse jury in the county. He stated that he had never raised the issue of a systematic exclusion of Negroes from juries…' *Cobb v. Balkcom*, 339 F.2d at 98. Here is the sworn

Appendix II

testimony of southern lawyers and county officials with personal experience in cases involving Negro defendants. None of them remember more than one time when a white lawyer raised the issue of systematic exclusion for a Negro client. *Henry v. Mississippi*, supra; *Whitus v. Balkcom*, supra. See Federal Habeas Corpus: The Import of the Failure to Assert a Constitutional Claim at Trial, 58 Va.L.Rev. 67 (Jan.1972)

BIBLIOGRAPHY

Ables, Verniece Gilmore. Telephone interview with the author, Yazoo City, MS.

Albin, Edwin (Jack). Telephone Interview with the author, Kosciusko, MS.

Alderman, Eloise. Interview with the author, Lexington, MS.

Ancestry.com and the Church of Jesus Christ of Latter-Day Saints. *1880 United States Federal Census*. Census Place: Newport, Attala, MS. Roll 641, Family History Library Film 1254641, Page 132C, Enumeration District 017, Image 0266.

Ancestry.com. *1850 United States Federal Census*. Provo, UT: Ancestry.com Operations Inc., n.d. Images reproduced by FamilySearch. Census Place: Township 16R 5E, Attala, MS. Roll M432_368, Page 122B, Image 299.

———. *1860 United States Federal Census*. Provo, UT: Ancestry.com Operations Inc., n.d. Images reproduced by FamilySearch. Census Place: Township 12 Range 5, Attala, MS. Roll M653_577, Page 472, Image 472, Family History Library Film 803577.

———. *1870 United States Federal Census*. Provo, UT: Ancestry.com Operations Inc., n.d. Census Place: Beat 4, Attala, MS. Roll M593_722, Page 122B, Image 248, Family History Library Film 552221.

———. *Mississippi Marriages, 1826–50*. Provo, UT: Ancestry.com Operations Inc., 1999.

———. *1900 United States Federal Census*. Provo, UT: Ancestry.com Operations Inc., 2004. Census Place: Newport, Attala, MS. Roll 800, Page 17A, Enumeration District 0009, Family History Library microfilm 1240800.

Bibliography

———. *1940 United States Federal Census*. Provo, UT: Ancestry.com Operations Inc., Census Place: Newport, Attala, MS. Roll T627_2008, Page 13B, Enumeration District 4-16. Original data from U.S. Bureau of the Census. *Sixteenth Census of the United States, 1940*. Washington, D.C.: National Archives and Records Administration, 1940.

———. *1910 United States Federal Census*. Provo, UT: Ancestry.com Operations Inc., 2006 Census Place: Beat 4, Attala, MS. Roll T624_732, Page 13A, Enumeration District 0009, Family History Library microfilm 1374745.

———. *1930 United States Federal Census*. Provo, UT: Ancestry.com Operations Inc., n.d. Census Place: Beat 1, Holmes, MS. Roll 1148, Page 9B, Enumeration District 4, Image 789.0, Family History Library microfilm 2340883. Original data from U.S. Bureau of the Census. *Fifteenth Census of the United States, 1930*. Washington, D.C.: National Archives and Records Administration, 1930.

———. *1920 United States Federal Census*. Provo, UT: Ancestry.com Operations Inc., 2010. Images reproduced by FamilySearch. Census Place: Newport, Attala, MS. Roll T625_869, Page 10B, Enumeration District 10, Image 924.

———. *U.S. World War II Army Enlistment Records, 1938-1946*. Provo, UT: Ancestry.com Operations Inc., 2005. Original data: Electronic Army Serial Number Merged File, 1938-1946. World War II Army Enlistment Records; Records of the National Archives and Records Administration, Record Group 64; National Archives at College Park, College Park, MD.

Attala County Deed Records, 1856 to 1900. Microfilm on loan from the Church of Latter-Day Saints (LDS) Library, Salt Lake City, UT.

Attala County Marriage Records. www.attala.msghn.org.

Attala Historical Society. Kosciusko: Attala History. http://www.rootsweb.ancestry.com/~msahs/history.html.

Branch, Eileen Netherland. Interview with the author, Ridgeland, MS.

Branch, James L. Interview with the author, Ridgeland, MS.

Branch, Jim H. Telephone interview and e-mail correspondence with the author, Birmingham, AL, July 2013-December 2013.

Branch, Jimmy Dale. Telephone interview with the author, Jackson, MS.

Breedlove, Ann, research librarian. Mid-Mississippi Library System, Kosciusko Library. Interview and e-mail correspondence with the author, Kosciusko, MS, April 2013-October 2013.

Buchanan, Sarah Winter. Telephone interview with the author, Houston, TX.

Bibliography

Cabell, James Branch. *Branchiana: Being a Partial Account of the Branch Family in Virginia*. Whittet and Shepperson, Richmond, VA, 1907. http://archive.org/stream/branchianabeingp00cabe#page/n13/mode/2upw. Microfilm on loan from LDS Library, Salt Lake City, UT.

———. *Branch of Abingdon: Being a Partial Account of the Ancestry of Christopher Branch of "Arrowhattocks" and "Kingsland" in Henrico County, and the Founder of the Branch Family in Virginia*. Microfilm on loan from LDS Library, Salt Lake City, UT.

Covington, Duncan C. Telephone interview with the author, College Station, TX.

Cox, Keneisha, clerk, Archives Department, Parchman State Prison. Telephone interview with the author, Drew, MS.

Craft, Thomas. Telephone interview with the author, Kosciusko, MS.

Criswell, Bettye Porter. Telephone interview with the author, Pickens, MS.

Cushman, H.B. *History of the Choctaw, Chickasaw and Natchez Indians*. Reprint. Norman: University of Oklahoma Press, 1999.

"Edmond Favor Noel: Thirty-seventh Governor of Mississippi: 1908–1912." Mississippi History Lesson Online. http://mshistorynow.mdah.state.ms.us/articles/265/index.

Edwards, HoneyBoy. *The World Don't Owe Me Nothing*. Chicago: Chicago Press Review Incorporated, 1997.

Engle, William. "Fighting Lady Editor." *Milwaukee Sentinel*, July 6, 1947.

Fisher, Grace, communications director, Mississippi Department of Corrections. Telephone interview with the author, Jackson, MS.

Garrett, Maggie McCrory. Telephone interview and e-mail communication with the author, April 2013–October 2013.

Haber, Roy. Telephone interview with the author, Eugene, OR.

Haffey, Helen Branch. Telephone interview with the author, Ebenezer, MS.

Harthcock, Raiford E. Telephone interview with the author, Vicksburg, MS.

Hattiesburg Statesman. Archive copies accessed via www.archives.com.

Hendrickson, Paul. *Sons of Mississippi*. New York: Alfred Knopf, 2003.

Historical Records of the Mississippi Tax Commission. http://opac2.mdah.state.ms.us/rgfindingaids/series1827.html (accessed August 4, 2013).

History of Holmes County, Mississippi. http://www.rootsweb.ancestry.com/~msholmes/index.htm.

Hodges, Mae Bess Branch. Telephone Interview with the author, Pearl, MS.

Hodges, Ms., deputy clerk, Holmes County Chancery Clerk's Office. Telephone interview with the author, Lexington, MS.

Holmes County Herald. Archive copies accessed at http://hch.stparchive.com.

Holmes County Marriage Records. Holmes County Circuit Clerk's Office, Lexington, MS.

Hutchinson, Kelly. Telephone interview with the author, Attala County, MS.
Kempton, Murray. "What Have They Got to Live For?"://www.soc.umn.edu/~samaha/cases/kempton_what_to_live_for.html. Lexington, MS, 1955.
Laurel Leader-Call. Archive copies accessed via www.archives.com
Lawson, Laura Gilmore, librarian, Lexington Library. Telephone interview with the author, Lexington, MS.
Lemon, Andrew. Interview with the author, Goodman, MS.
Lepard, John Henry. Telephone interview with the author, Goodman, MS.
Lexington Advertiser. Archive copies available on microfilm at Mississippi Department of Archives and History(MDAH), Jackson, MS.
The Living New Deal. livingnewdeal.berkeley.edu (accessed December 12, 2013).
Martin, William R. Telephone communication and e-mail correspondence with the author, Madison, MS.
McCrory, Andy. Photos of Seneasha Cemetery, Attala County, MS. www.findagrave.com.
McCrory, Sonny. Interview with the author, Durant, MS.
McMillan, Stokes. *One Night of Madness.* Houston, TX: Oak Harbor Publishing, 2009.
Minor, Bill. "The Strange Story of Eddie Noel." http://www.desototimes.com/articles/2010/08/13/opinion/doc4c630b8750d61262823948.txt.
Mississippi Bureau of Vital Statistics. State death records accessed through state contract with .
Mississippi Sovereignty Commission Files. Accessed on Mississippi Department of Archives and History (MDAH) website.
Mississippi Supreme Court records. www.Public.Resource.org and at www.findlaw.com.
Moore, Jennette. Interview with the author, Goodman, MS.
Morris, Willie. *North Toward Home.* Boston: Houghton Mifflin Company, 1967.
Nance, Billie McCrory. Interview with the author, Goodman, MS.
National Archives Records Administration. Digital archives, www.nara.gov.
National Archives Records Administration. Textual archives, 700 Pennsylvania Avenue, NW, Washington, D.C. 20408.
National Register of Historic Places. www.nps.gov/nr..
Neale, Gay, and Henry L. Mitchell. *Brunswick County, Virginia 1720–1975.* Brunswick County, VA: Brunswick County Centennial Team, 1975.
New Deal Art during the Great Depression. www.wpamurals.com.
NPR. *Eyes on the Prize: America's Civil Rights Movement 1954–1985.* American Experience Presentation, 1987.

Oshinsky, David. *Worse Than Slavery: Parchman Farm and the Ordeal of Jim Crow Justice.* New York: Free Press Paperbacks / Simon & Schuster Inc., 1997.

Povall, Allie. *The Time of Eddie Noel.* Concord, NC: Comfort Publishing, LLC, 2010.

Robben, Janine. *Profiles in the Law: Letters from Parchman Prison Farm.* Tigard, OR: Oregon State Bar Bulletin, 2007.

Roberts, Kelly, deputy clerk, Leflore County Chancery Clerk's Office. Telephone interview with the author, Greenwood, MS.

Sample, Rufus. Telephone interview with the author, Goodman, MS.

Siddons, Bill. Interview with the author, Lexington, MS.

Smith, Hazel Brannon. *Looking at the Old South Through Hazel Eyes.* Alicia Patterson Foundation Fellowship Papers, 1983.

Sojourner, Liz Lorenzi. GOT TO THINKING: *How the Black People of 1960s Holmes County, Mississippi Organized.*. Praxis International: Duluth, MN, 2001.

———. THE SOME PEOPLE OF THAT PLACE: *1960s Holmes Co., Mississippi—The Local Black People and Their Civil Rights Movement.* Photographs, Documents and Text. Duluth: University of Minnesota–Duluth Tweed Museum of Art, 1999.

Spence, Mac, and Louise Spence. *The History of Leake County, Mississippi: Its People and Places.* Dallas, TX: Curtis Media Corporation, 1984.

Star-Herald. Archive copies accessed via microfilm by Ann Breedlove, research librarian at Mid-Mississippi Library, Kosciusko, MS.

U.S. Appeals Court Records. www.Public.Resource.org and www.findlaw.com.

U.S. Bureau of Prisons, Atlanta, GA, and Leavenworth, KS. Freedom of Information Act requests submitted online, July 2013.

U.S. Draft Registration and Military Records. www.ancestry.com.

Ward, John Morris. Telephone interview with the author, Kosciusko, MS.

Whalen, John. *Maverick Among the Magnolias: The Story of Hazel Brannon Smith.* Bloomington, IN: Xlibris Corporation, 2001.

Whitt, Jan. *Burning Crosses and Activist Journalism.* Lanham, MD: University Press of America, 2010.

Wigginton, Patty Branch. Telephone interview with the author, Kosciusko, MS.

Winter, Inez. Telephone interview with the author, Kosciusko, MS.

Winter, Matthew, inmate, Mississippi Department of Corrections. Interview with the author, County Farm Unit, Raymond, MS.

INDEX

A

Ables, Maxine. *See* Branch, Maxine Ables
Ables, Myrtle Criswell 77
Ables, Walter Talmadge "Tal" 72
Ables, William Chester "Billy" 77
Amelia County, VA 117
Atlanta Federal Penitentiary 25, 75
Attala County 31, 32, 34, 41, 42, 46, 50, 51, 52, 60, 63, 66, 67, 69, 72, 74, 77, 81, 84, 86, 101, 103, 106, 110, 116, 118
Azar Brothers 59

B

Barnes, John Henry 67
Barnes, Johnny 108
Barnes, Willie 107, 108
Barrett, Pat M. 24
Belt, Jewy 106
Belzoni, MS 71
Big Black River 32, 52, 56, 59, 73
Bilbo, Governor Theodore 48
black market tax law 60
Blue Flame, the 30, 59, 63, 64, 65, 67, 73, 86, 98, 99, 102, 107, 108

Booth, C.C. 25
bootleggers 7, 12, 22, 30, 51, 56, 60, 61, 62, 65, 74, 110, 113
Boyette Crossing School 52
Branch, Benjamin Harrison 37, 41
Branch, Bessie Dickerson 50, 52
Branch, Callie 37
Branch, Christopher 117
Branch, Clark Commander 39, 41, 118
Branch, Claudia Baldridge 7, 40
Branch, Doc. *See* Branch, Frederick Mabry
Branch, Edward Arthur "Ed" 39
Branch, Edward Tillman 7, 31, 75, 78, 84, 117, 118
Branch, Edward Tillman, Jr. 45, 78
Branch, E.T. 34, 35, 37, 41, 67
Branch, Frederick Mabry 37, 60
Branch, Henry Clay 37
Branch, Hoye 71
Branch, James Edward 45, 52
Branch, Jimmy Dale 79
Branch, Joyce Dean 79
Branch, Linnie Mae McCrory 78
Branch, Mae Bess 45, 51, 78, 79
Branch, Mamie 37
Branch, Mary Addie 117

INDEX

Branch, Mattie Allen 40
Branch, Maxine Ables 79
Branch, Nettie Ousley 37, 84
Branch, Rosa Mae Langford 51
Branch, Rose Mahan 78
Branch, Tillman 7, 13, 30, 37, 39, 41,
 45, 50, 51, 53, 59, 60, 61, 62,
 66, 75, 83, 85, 86, 91, 93, 98,
 99, 101, 103, 105, 107, 108,
 110, 111, 112, 113, 116
Branch, William Thomas 37
Brannon, Miss Hazel 22
Bruce, Y.B. 25
Brunswick County, VA 117
Buffalo Community 34, 102
Byrd, Richard F. 61
Byrd, Sheriff Richard F., Jr. 26

C

Cabell, James Branch 117
Camp Shelby, MS 41
Castallian Springs 58
Central High School 12
Charles City, VA 117
Chenoa 19
civil rights 21, 26
Civil Rights Act of 1964 90
Civil Rights Commission 89, 103
Clifton Plantation 16
corn mash 29
corn whiskey 29
Cotton, Jim 49
Coxburg, MS 25
Crawley, David E., Jr. 85, 87
Cunningham, J.W. 25

D

de la Beckwith, Myron 12
Dickard's Store 12
Dickard, Willie Ramon 12
Dickerson, Bessie 45, 51, 69
Dickerson, Jim 50
Doughty, John L., Jr. 68
Drew, MS 97

Dromgoole, Reverend Edward 117
Durant, Captain. *See* Durant, Louis
Durant, Charles 56
Durant, Louis 56
Durant, Margaret 56
Durant, Michael 56
Durant, MS 16, 22, 29, 51, 56, 58, 66,
 67, 68, 74, 78
Durant News 24
Durant, OK 58
Durant, Pierre 56
Durant, Syllan 56
Dyer, Howard 24

E

Eagle's Nest, the 73
Edwards, HoneyBoy 66
Edwards, W.L. 25
Egypt Plantation 19
Electro-Chemic Institute, New Orleans,
 LA 37
Ethel, MS 106
Eureka Masonic College 16
Evers, Medgar 12

F

Farish Street Baptist Church 12
Farmer, S.V. 25
Ford, Allen 108

G

Gage, R.H. 25
Goodman, MS 7, 16, 32, 35, 45, 49,
 52, 56, 63, 66, 67, 68, 70, 71,
 77, 79, 81, 86, 102, 106, 107,
 108, 116
Gordon, A.S. 25
Grace, W.E. 25
Grantham, O.G. 25
Green Lantern 59
Greenville, MS 59
Greenwood, MS 12, 19, 51, 69, 82

H

Haber, Roy S. 90
Haffey, Helen Branch 45, 51, 79
Haffey, Thomas E. 78
Harthcock, Claude 25
Helms, Nick 25
Henry, Lucy Lula Trigleth Pettus 72
Henry, Sam 72
Hills of Mississippi 32
Hill, W.E. 25
Hinds County Courthouse 118
Hocutt, Willie R. 25
Hodges, Mae Bess Branch 45, 51. *See* Branch, Mae Bess
Hodges, Sam Francis, Jr. 78
Holmes County, MS 15, 21, 23, 32, 45, 51, 55, 59, 60, 62, 65, 68, 73, 74, 75, 78, 85, 87, 89, 95, 98, 99, 110, 111, 115, 116, 117, 129, 142
Holmes, Governor David 16
Holmes, Johnny 83
honkytonk 65
Hughes, Reverend J.R. 51
Hutchinson, Bailey 67

I

Indianola, MS 71
Inverness, MS 71
Isola, MS 71

J

James, Elmore 68, 107, 115, 116
James River 117
James River Plantations 117
Johnson, Jim 52
John Tye's Place 49
Jones, Laura Branch 40
juke joints 22, 65, 66, 68, 115, 116
Junior's Juke Joint 68

K

King, Dr. Martin Luther, Jr. 12
King Edward Hotel 116
Kingsland Plantation 117
Kosciusko, MS 31, 32, 35, 42, 59, 83, 85, 98, 101, 103, 106, 108
Kościuszko, Tadeusz 34
Kuykendall, Dr. J.C. 106
Kyzer, Bit 25

L

Langford, Edward 51
Langford, Rosa Mae 51
Langford, Tom 51
Langford, Willie Lee 51
Leake County, MS 118
Leake County, MS Police Board 118
Leflore County, MS 19, 51
legalization of liquor in Mississippi 59
Lemon, Andrew 63
Leon Turner 34, 66, 74, 79
Lepard, John Alec 46
Lepard, John Henry 46, 49
Lexington Advertiser 24
Lexington MS 16, 19, 22, 26, 29, 51, 52, 59
Lexington, MS 63, 68, 74, 85, 86, 93, 111, 116
Little Red Schoolhouse. *See* Eureka Masonic College
Long Branch 63, 65, 72, 81

M

Mabry, Mary Ann 35
Malone, Deputy Sheriff John Pat, Sr. 12
Mandy's Place 49
Marcello, Carlos 70
Mayo, Luther 25
McCrory, John C. 52
McCrory, Linnie Mae 52
McCrory, Sonny 59
McDaniel, Catherine Branch 40

Index

McDaniel, Ezma Branch 40
McMillan, Stokes 66
Meredith, James 12
Mile-a-way 59
Mileston Plantation 93
Miller, Aleck 68
Mississippi Delta 19
Mississippi Department of Corrections 42
Mississippi school desegregation 62
Mississippi State Tax Commission 59
Mississippi Supreme Court 26, 140, 141, 142, 145
Moody, James Robert 45, 69
moonshine 29
Morris, Willie 56
Mullins, Hogjaw 74
Murtagh, Sheriff Walter J. 23, 61, 62

N

Neilson, Alice Tye 116
Netherland, R.L. 25
Newport, MS 31, 35, 45, 77
Noel, Eddie 12, 99
Noel, Edmond Favor 55, 59, 116
Noel, Lu Ella 12

O

Order of the Eastern Star 16
Ousley, Nettie Artissa 31
Ousley, Nicholas Nixon 35

P

Parchman State Penitentiary 48, 51, 66, 74, 87, 90, 91, 97, 102, 105
Parks, Clytee 64, 67, 81, 102, 103
Peeler, Edward Earl 106
Peeler, Sam 106
Pettus, Annie Lee Langford 51
Pettus, Tom 51
Pettus, William Elza 51
Povall, Allie 12
Pushmataha 56

R

Ragland, Arthur 118
Ragland, Elizabeth Smith 118
Ragland, John 118
Ragland, Winiford 31, 118
Rainbow Garden 59
Reynolds, George G. 25
Robertson, Attorney James 90
Roosevelt's New Deal 58

S

Seneasha Cemetery 37, 53, 72, 79, 83
Shi Ne Yak 56
Sidon, MS 51
Simmons, Hubert 83
Simmons, Mae. *See* Simmons, Hubert
slot machines 23, 71
Smith, Hattie Coleman Cade 62
Smith, Hazel Brannon 23, 25, 60, 62
Smith, Sheriff Andrew 62, 67, 110
Smith, Walter Dyer 22, 27
Sojourner, Liz Lorenzi 21
Student Nonviolent Coordinating Committee (SNCC) 11

T

Taylor, Allene Wallis 62
Taylor, Bluford 62
Taylor, George Peach 90
Taylor, Percy Paul 62
Tchula, MS 19, 26, 62
Thompson, Allen C. 11
Tillman's Place 59
Tillman's store. *See* the Long Branch
Toberoff, Isadore 58
Tougaloo College 12
Treaty of Dancing Rabbit Creek 32
Treaty of Doak's Stand 15
Tye House 16

U

U.S. Open in Foxhunting 58

INDEX

V

Varnado, H.R. 25
Veasley, Miss 107
Voting Rights Act 95

W

Waddell, J.V. 25
war bond sales in Holmes County, MS, in 1945 60
Whalen, John A. 27
whiskey stills 29
White Citizens Council 12, 26
White, J.A. 83
White Pig, the 59
Wigginton, Patty Branch 49, 79
Wilkerson, Floyd 25
Wilkes, Claud C. 22
Williamson, Sonny Boy 68
Williamson, Sonny Boy, II. *See* Miller, Aleck
Winfrey, Oprah 34, 106
Winter, Andrew 101
Winter, Inez 98
Winter, Lenora 101
Winter, Matthew 11, 13, 85, 87, 90, 93, 98, 105, 110, 112, 113
Woods, Joyce Dean Branch. *See* Branch, Joyce Dean

Y

Yazoo County, MS 15, 56
Yazoo & Mississippi Valley Railroad 19
Young, Stella Branch 40, 72

ABOUT THE AUTHOR

Janice Branch Tracy is a sixth-generation Mississippian with deep roots in Attala and Holmes Counties. She was born in the Mississippi Delta and grew up in Jackson, where she graduated from Central High School. After attending the University of Mississippi, Tracy moved out of the state and began a thirty-year career with the U.S. Government, during which time she lived and worked in several states, including Arkansas, Louisiana, Kentucky and Texas, before she retired in 2004. Her love of reading, writing and research, as well as her avid interest in genealogy, led her to start a genealogy blog in 2008, where she continues to write about family history. In 2011, and again in 2013, her blog, Mississippi Memories, was listed among *Family History* magazine's Top 40 GenealogyBlogs. She is married and is the mother of five children, stepmother to two daughters and grandmother of eleven. In her spare time, she enjoys gardening, reading and some occasional travel. This is Janice Tracy's first book.

Visit us at
www.historypress.net

This title is also available as an e-book